Higher Ground

Chrysalis Children's Books

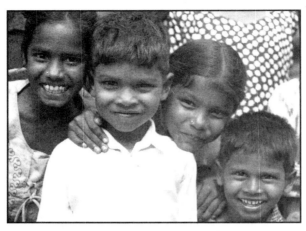

This book is dedicated to the children of the 2004 tsunami,
those who survived and those who did not.

Visit the *Higher Ground* website at
www.highergroundproject.org.uk

First published in the United Kingdom in 2005
by Chrysalis Children's Books, an imprint of Chrysalis Books Group plc
The Chrysalis Building, Bramley Road, London W10 6SP
www.chrysalisbooks.co.uk

Associate Publisher Hannah Wilson
Art Director Sarah Goodwin
Designer Jonathan Vipond
Map Illustrator Mark Franklin
Production Manager Beth Sweeney
With editorial assistance from Jennie Morris and Camilla Lloyd

British Library Cataloguing in Publication Data for this book
is available from the British Library.

ISBN 1 84458 581 6

Printed by Creative Print & Design (Wales), Ebbw Vale

2 4 6 8 10 9 7 5 3 1

This book can be ordered direct from the publisher.
Please contact the Marketing Department. But try your bookshop first.

Contents

Foreword

We saw the television pictures, heard the reports, all in disbelief. I'm not sure I knew what a tsunami was until Boxing Day 2004. The geography of the affected region suddenly became familiar – the Maldives, Sri Lanka, southern India, Thailand, the Andaman and Nicobar Islands, Somalia and Indonesia. The numbers of dead rose inexorably, a rising gauge of tragedy that reminded us daily, hourly, of the enormity of what had happened, of what was still happening. Up towards 300,000 dead they told us, and millions more homeless and destitute.

How does the human mind cope with such a dreadful happening? We are, sadly, much more used to dealing with manmade catastrophes. There have been wars, massacres and holocausts. There has been the destruction of species, the desolation of forests, global warming, famine and disease. With all of these we can conveniently, and perhaps comfortingly, point to cause and effect, we can begin to understand the whys and the wherefores. We can apportion blame. We can feel guilt and shame. We can resolve to do better in the future, not to let it happen again. We can believe that some good will come out of it after all, if we learn our lesson.

But what can we do, what can we think, when natural disasters such as this tsunami occur? We can send in our money to help the appeal, we can collectively and individually grieve for the dead and the bereaved. We can pray for them. But all of this, for most of us, is necessarily from a distance. We did all this, for weeks afterwards, from the comfort of our homes that Boxing Day. And the television pictures and the news reports came from

afar too, beamed across the world, dramatic scenes first of water surging inland with unimaginable destructive force, then of the desolation and despair that followed. We wanted so much to reach out and help. If it was in our town, in our street, we would, most of us, have been out there helping. The whole world seemed to want to put its arms around the survivors and hold them fast. But we couldn't. We simply couldn't get close enough.

We could, because it didn't happen to us, neatly dismiss it as a natural disaster, or God's will. We could sigh sadly and say, 'Well, these things happen.' So they do, so they do, but when they do, our human duty, it seems to me, is to understand as best we can the nature of the suffering endured, and to support the survivors as they build a new future for themselves.

This wonderful book, conceived by Anuj Goyal, does both. It was born of his personal sense of guilt and powerlessness in the face of the unfolding disaster of the tsunami. He inspired sixteen of our finest writers, the great illustrator Michael Foreman and *Chrysalis Children's Books* to come together to make a book of stories that brings us closer to what happened, to those who survived and those who did not. This book will serve also to help fund the long-term reconstruction projects that are so vital to the future of all the people living in those faraway lands where the tsunami hit. Such a book is a fine and important thing for them, for all of us.

MICHAEL MORPURGO
May 2005

Introduction

Higher Ground is an anthology of short stories, each based on the remarkable experiences of children who survived one of the worst natural disasters in living memory – the Boxing Day tsunami.

On the morning of the 26th December 2004, a massive earthquake, more powerful than thousands of atomic bombs exploding at the same time, shook the floor of the Indian Ocean near the north coast of the island of Sumatra, Indonesia. The earthquake sent giant waves to the coasts of more than a dozen countries on two continents. The map on pages 10–11 shows the regions most affected by this 'tsunami' (the word means 'harbour wave' in Japanese).

Nearly 300,000 people, including thousands of tourists, were swept to their deaths by the tsunami that day. More than one third of the people who died were children. They died because they weren't fast or strong enough to escape the waves. In other words, they died *because* they were children. And so the stories from

What is a tsunami?

A tsunami (soo-NAH-mee) is a series of large waves generated by a massive displacement of seawater. The displacement is usually caused by an underwater earthquake or a landslide in or near the ocean. The speed at which a tsunami travels and its height depends on the depth of water through which it passes. In shallow water, often found near the coast, a tsunami's speed decreases, but its height increases – waves as high as 20m hit the coast of Sumatra. In deep water, the speed increases, but the height of the waves decreases. The tsunami headed for Sri Lanka at speeds of up to 800km/h, but the waves were only 30cm high. Specific coastal and seabed features also affect the motion of tsunami waves.

those children who did survive are quite remarkable. The languages they spoke, the clothes they wore and their ways of life may have been different, but the tales they told seemed to touch something deep inside every one of us.

The stories in this anthology have been written by sixteen of our best children's authors. Together they present a rainbow of cultures in seven of the affected regions across Asia and Africa. But at the heart of every story is a real-life experience, which in most cases was related by a child to a worker from one of five international charities.

Escaping the tsunami was not the end of the ordeal for the survivors. Most had to cope both with their losses and with the prospect of rebuilding their lives. Starting again was their biggest challenge yet. But this time, of course, they were not alone. The whole world was with them.

As images of suffering poured from the media in the days that followed, the world seemed to come together in its desire to help. This was not a war dividing people, but an uncontrollable force of nature – an 'act of God', some felt – that humbled and united people. The survivors were no longer strangers in faraway lands, but friends in need. Something had to be done to help, and you made sure that it was – you gave and

How disaster-relief agencies work

International disaster-relief agencies aim to save lives and protect people by providing food, water, temporary shelter and essential medicines. These supplies are delivered to major ports by sea and air and then distributed in smaller loads by road or helicopter. As the tsunami floods made many regions inaccessible by road, supplies often had to be dropped by aircraft. Agencies also help to clean up debris, search for survivors and ensure the protection of the most vulnerable people. After an initial relief effort, agencies aim to restore communities by enabling displaced people to return and by helping people find a way to earn money. Public health and social services are re-established as soon as possible, buildings constructed and schools set up. Relief agencies work with governments to increase resilience to future disasters.

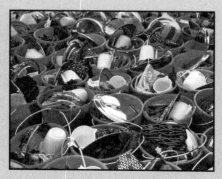

These buckets containing essential supplies such as cooking utensils and clothing were distributed by aid workers in tsunami-hit regions of southern India.

gave and gave! You donated money, collected clothes and blankets, and organised appeals to raise funds.

To help governments and charities cope with this disaster, the world donated an amazing £7 billion. Because of your generosity, government and charity workers were able to provide immediate emergency aid to the affected regions in the days, weeks and months that followed. And those survivors who gained the most from your generosity were the ones in need of the greatest care, attention and protection: the children.

To complete each extraordinary tale of survival in this anthology, a short update explains how each child, or how a particular region, has progressed since the tsunami. Most of the updates were provided by the charity workers who collected each child's story and who have worked with the children ever since. A section at the back of the book (pages

Problems that charities face
Charities and agencies plan to improve people's lives, rather than return them to the poverty of the past, and this requires the careful organisation of donations. In some areas, political issues and corruption have affected how money and supplies have been distributed. Non-tsunami charities were worried that they would receive fewer donations, but some reports suggest that the tsunami has provoked such a feeling of international sympathy that people are now more likely to donate to other charitable causes.

158–159) gives more detail about the work of each charity. And a colour section in the centre shows a collection of illustrations drawn by children from all over the world as part of their healing process.

The updates paint a bright picture of these children's future – a future that would have been bleak without the hard work of charities funded by you, your relatives, your friends and your schools. These children are beginning to feel safe again, to feel loved again, and, most importantly, to smile again – and a large part of this is because of you!

So, thank you for your generosity: it is helping to write the happy endings to the stories of these children and of millions more.

ANUJ GOYAL

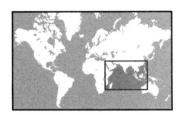

Affected Regions

The epicentre of the earthquake that caused the tsunami was on a fault line close to the city of Banda Aceh on the Indonesian island of Sumatra. The tsunami waves moved outwards in all directions from the epicentre, travelling at speeds of up to 800 kilometres per hour.

Southern India
The tsunami waves swept 3km inland in many parts of the southeast coast of India. Almost 9,000 people are known to have died and 150,000 lost their homes.

Somalia
The worst-hit country in Africa was Somalia. About 150 to 200 people lost their lives and thousands left homeless. The tsunami destroyed freshwater reservoirs, causing water-shortage problems.

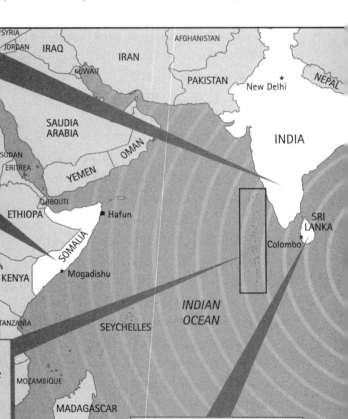

Maldives
At least 81 people were killed when the tsunami destroyed twenty of the 199 low-lying islands that make up the Maldives. It is estimated that more than £200 million is needed to rebuild the islands.

Sri Lanka
More than 31,000 lost their lives when the southern and eastern coastlines of Sri Lanka were hit by the tsunami. About 400,000 people, mainly those who work in the fishing and tourism industries, were left without jobs.

The waves hit many of the countries that border the Indian Ocean, striking nearby Sumatra about 15 minutes after the earthquake, Thailand about an hour and quarter after that and reaching Somalia seven hours after the quake.

The map below highlights the countries that were most affected and it is from these countries that the stories in this book originate.

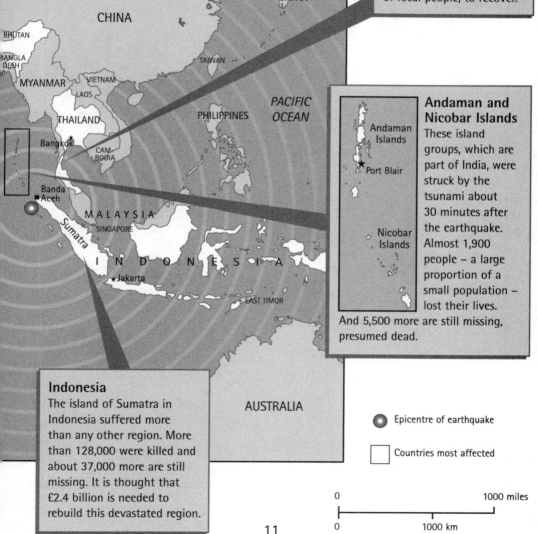

Thailand
The west coast of Thailand suffered losses of more than 5,300 people. Of these, 2,200 were tourists from 36 countries. It will take many years for the tourist industry, which provides jobs for thousands of local people, to recover.

Andaman and Nicobar Islands
These island groups, which are part of India, were struck by the tsunami about 30 minutes after the earthquake. Almost 1,900 people – a large proportion of a small population – lost their lives. And 5,500 more are still missing, presumed dead.

Indonesia
The island of Sumatra in Indonesia suffered more than any other region. More than 128,000 were killed and about 37,000 more are still missing. It is thought that £2.4 billion is needed to rebuild this devastated region.

Epicentre of earthquake

Countries most affected

0 1000 miles

0 1000 km

11

At Any One Moment

JUDY ALLEN

At any one moment, on this small planet, millions upon countless millions of things are happening. Sun and wind and rain are touching the surface in different places. Tides are turning, rivers flowing, trees growing or dying, plants flowering or dropping seed. Birds and animals and insects are feeding or fighting or mating; whales are singing under the sea, crabs are clicking their way across shingle, spiders are stringing webs between branches.

People are doing even more complicated things – travelling and trading, fighting and harvesting, making and mending, laughing, crying, telling stories. The things they are doing may affect others, thousands of miles away. War in one country will send desperate refugees into another. A decision to buy a mahogany table will damage a rainforest on the other side of the Earth. A truck made in Europe may be driven in Australia; coir mats woven in Asia may cover floors in North America; green beans picked in Kenya may be eaten in Scotland. Even so, most people are aware only of their own small world, and many believe their own small world is all there is.

Eleven-year-old Sherif, sitting in a dugout boat with his older brother, was not aware of anything beyond the Somalian fishing village of Hafun, where he lived, and the offshore shallows where he was watching his brother fish.

If he had thought about other people, other events, in other places, he would probably have thought of things that happen on the surface. The things that happen deep within the Earth, or even just below it, are unknown to most people and understood by only a few – but these things

may have the greatest impact of all.

When two of the enormous plates that form the crust of the Earth shifted, the effect shuddered outwards for thousands of miles. The plates were deep under the Indian Ocean, and it was as though a vast bowl of water had been tilted, causing the liquid to swill back and forth until it found a new level. It was a massive and dangerous change, but one that carried no obvious warning.

No obvious warning – yet a kind of warning did travel ahead of the disaster, a strange and subtle message that was picked up only by some, almost none of them human.

In Hafun, it was the camels that sensed danger coming from the sea. Their strange, braying screams may have alerted the sheep and goats. Or perhaps they, too, picked up sounds too deep for human ears. The animals ran, kicking up the yellow dust of the dry season. Their retreat took them away from the sea towards higher ground.

To Sherif, though, it didn't seem that anything was coming – instead he saw that something was going away. Incredibly, the sea was moving away from the shore.

He stared as the vast sweep of water was pulled back like a huge bedcover, revealing things he normally saw only if they had been fished up, or if he had dived down for them. Stranded fish flapped and writhed on the wet sand. Great swathes of seaweed lay limply, their damp surfaces glittering in the sunlight. Things long lost over the sides of fishing boats were revealed again – odd shoes, weights for nets, a punctured football.

His brother started to laugh – it was all so extraordinary, a trick played by the ocean. He saw a large lobster walking solemnly along the seabed, no longer safely hidden by a metre of water, and jumped out of the grounded boat to catch it.

Others were running down the beach to collect the sudden bounty of fish, so easily caught now they had no water to twist and turn through.

Sherif stayed where he was. He was frightened, without knowing why. He watched his brother walk just a few steps from the boat – and then looked beyond him. The sea had vanished almost to the horizon – but the horizon didn't look as it should. The fishing boats of the older men, which

had been further out than Sherif and his brother, were moving rapidly up and down, just where the sea met the sky, as if in some terrible storm.

In the same moment, he saw the wave. It rose up like a mountain, either hiding or engulfing the distant boats – he couldn't tell which. And then it began to race towards the land.

Sherif screamed a warning to his brother, but his voice was lost in the immense roaring of the approaching water, a three-storey-high wall that raged towards the land with the sound of a dozen freight trains. Not even the long, loping strides of the camels could have outrun it. Like so many of the animals in the great semicircle of lands where the water hit, they were safe. The people, though – especially the people who had followed the sea to collect what it had left behind – had no chance.

Sherif clung to the sides of the dugout. His mouth was open and the feeling in his chest told him he was screaming, but all he could hear was the thundering water. It surged over his brother – and over the others too, but he saw only his brother – and it lifted the dugout and carried it in across the sand, changing land into sea in an instant.

As the water levelled out over the town, he saw cars under the surface. Empty boats, some upside down, nudged the sides of his dugout. Floating behind, face down, was the body of his brother – as though he was still trying to reach the safety of their little fishing boat.

Then the wave drew back, as waves do, taking Sherif's boat and his brother's small, drowned body with it. Back it went, slowly and steadily, and people who had run to the safety of the hills began to return, thinking the water had gone, anxious to look for family, friends, whoever and whatever was left. They had time to get right into the town to begin their search.

The departing water had drawn Sherif's boat back out to the shallows again, and he stayed in it, shaking, calling for his mother, for his father, but unable to see either of them. His father always said, *Think before you act*, but Sherif didn't know what to think, he didn't know how to act.

The ocean had not yet found its new level. The second wave that rolled in was larger, nearly five storeys high, and black with the earth and dirt it had sucked up from the ocean floor on the thousands of miles of its violent journey.

It was high enough to shut out the sky, fast enough to outdistance a jet plane. It slammed into the town, destroying the wood-and-animalskin houses instantly, ripping the concrete buildings from their foundations, tearing up the acacia trees, drowning almost all who had run back from the hills.

It lasted no more than a few minutes, but its impact was beyond imagining.

Sherif's dugout was smashed into the roof of one of the few houses that had been left standing. When the water pulled back this time the boat stayed where it was, jammed into the rafters. He had been flung flat inside it; he was covered in bruises and scratches, his head hurt, his whole body hurt. He was crying for his brother, for his parents, and for himself.

The darkness came and it was night. The sea had settled, but in the town, no one moved, there was no sound. Sherif didn't have enough strength left to climb down to the ground – and he didn't want to be in the empty, silent, broken town that he could no longer recognise, that no longer looked at all like home.

He hid in his boat, the only safe place, and it seemed to him that he was the only one left alive in the entire world.

But the world was not emptied of people and now other messages were travelling. This time they didn't travel through the ground but along airwaves and within electrical pulses. This time the animals and birds were unaware of them; it was humans who understood. The rest of the world was hearing about the wave, the tsunami that had struck so many countries. Fifteen hundred dead, the messages reported. Then the figure rose to three thousand, then thirty thousand, and at last, when all the counting was done, they would speak of three hundred thousand lost. And these invisible messages brought, eventually, help – people, supplies, money, concern and love.

Sherif knew nothing of this, but he did know that as the sun rose and warmed him, he woke. For a few seconds, he thought he had dreamt the worst dream of his life, then he knew it had really happened.

He thought he heard voices, was sure he had imagined them, and chose not to sit up and look over the edge of the boat at the crushed and dead town.

The voices drew closer, men talking, women crying. This time he looked

and saw people, among them his father with two neighbours, gazing at the incredible destruction around them.

Sherif called out, and the relief and happiness on his father's face made him cry. He was helped down and his father hugged him, hugging him tighter when he heard that Sherif's brother was lost.

At that moment, in all the countries bordering the Indian Ocean, just as in Hafun itself, people were helping the injured, searching for the missing, examining wreckage, grieving for those who were lost and clinging to those who had survived.

In that same moment, all Sherif was aware of was the closeness of his father. He knew he must help to try to find his mother and the body of his brother, bury the dead and struggle to live in an achingly empty town that would have to be totally rebuilt. And he knew that he would suffer terrible nightmares, perhaps forever. But at least, unlike some, he was not alone.

UNICEF's work in Somalia
Hafun was the worst-affected village in Somalia. Furthermore, within days of the tsunami, the children who managed to survive, like Sherif, had two other deadly challenges to face – malnutrition and disease. In the days and weeks after the disaster, UNICEF moved quickly to immunise more than 1,135 children against measles and to provide them with vitamin supplements. To avoid diseases like cholera, which is spread by polluted water, UNICEF worked throughout affected communities in Somalia to rebuild water wells and toilet facilities, and it has now started the construction of an efficient waste-disposal system. Because of activities such as these, young survivors like Sherif can look forward to a healthy future.

Arti's Story

MALACHY DOYLE

'How old are you, Arti?'

She looks up at me, and down again quickly. Then slowly she lifts up a thumb, and one, two, three fingers. She stares at the last one, the little finger, still bent, still tucked into the palm of her hand. Eventually she lifts that one too. And, as she stares at her wide-open hand, tears fill her eyes once more, and her thumb, pointing away from her, drifts over and into her mouth.

'It's all right, Arti. We'll find your family. I shall look after you until we find them,' I say. And I hold her in my arms as she cries.

My name is Sulisna. I have two girls of my own, and I am one of the lucky ones. My husband is safe. My children are safe. My house is foul, though, as all the houses are, for the dust, the dirt, the smell of death is everywhere. But at least it is still standing. My husband has his own business, you see. He is a shopkeeper and we could afford a house of concrete, a house with two stories in the higher part of town.

I give thanks to Allah every moment of the day for sparing my family. I give thanks to Him, also, for bringing me little Arti to look after. For it is only right that we, the fortunate ones, should do everything we can for those who have nothing.

It was yesterday that she came to me – the day after the sea became the enemy of the people of Banda Aceh and changed our lives forever. I asked my husband to stay inside with our daughters. They were frightened, so frightened, that the wave might come again, but I needed to go out and see if I could help my neighbours in any way. Allah wanted me to.

The town was destroyed. It was dreadful. Bodies were floating in the mud. People everywhere were crying.

I came across some men in jeeps. I asked them how I could help. They brought me to a tent. Among the injured, waiting to be taken to hospital, was a small girl.

'She is alone,' one of the men whispered. 'We cannot find her family. She has a fever, but the hospitals can take only the worst cases. We need someone who will look after her.'

I agreed to take Arti home. My husband was surprised when I returned with her, but he is a good man and he understood. Sinta and Fitri, my two girls, were kind to Arti straight away. They knew that she was sad.

Last night, Arti's first with us, she woke up. 'Mama! Mama!' she cried. I tried to settle her but she stared blankly into my face. She was hot and sweating.

'Mama! Mama!' she cried again, holding out her arms.

I went to pick her up, but she knew then that I was not the Mama she wanted, the Mama she needed.

'Go away!' she cried, her hands turning to fists as if to force me back. Then she pulled the blanket over her head, curled herself into a tight little ball, and sobbed.

I have never felt so useless. 'I know I am not your Mama, Arti,' I said quietly, stroking her through the cover. 'But I will try my best to look after you until she returns.'

Eventually she poked her head out – I knew she could not stay down there long when she was so hot already. I offered her some water to cool her down, wiped the sweat from her forehead, and sat with her until she slipped back into sleep.

Oh, Arti. I went to see those men again today, to see if they had discovered any more about you. They told me that they had found your Uncle Bejo, up in the hospital. He is only young himself, too young to look after you, even when he is well again.

Bejo told them that he was there with you when it happened, at home with your mother and your two sisters. You were all eating breakfast when the cries and shouting began. 'Water! Water!' came the calls, and at first your uncle thought it meant that the monsoon rains had finally arrived.

He ignored it. He did not think it was important. But then the cries got louder and more desperate, and Bejo heard the sound of people rushing past their door. 'Run! Run! The sea is coming! The sea is coming!'

What did it mean? How could the sea come to Banda Aceh?

There was panic and confusion here, too. But we ran upstairs, myself and my family, and that is how we were saved. The walls of our house were strong, and we were high enough, and far enough from the sea for the waves not to reach us.

Arti's family were not so lucky. Bejo, her uncle, told the people in the hospital that he grabbed Arti by one hand and one of her sisters by the other. He already had a feeling that something bad was about to happen, for the house had begun shaking a few minutes before. As he began to make sense of the cries, he understood that a huge wave was coming, and that their fragile home could not withstand the force of the sea. Like other poor families, they lived in a simple wooden hut on the edge of town, and he knew that they must run, run for higher ground.

Holding on to the two girls, Bejo raced as fast as he could out of the house and away from the water. But the sea was furious with the people of Banda Aceh. It had no mercy. It did not want to let anyone escape.

The gigantic wave was three metres high when it hit the shore, and by the time it reached Banda Aceh it was full of cars and trees, huts and furniture. When this deadly wall of water caught up with Arti's family, her uncle was hit by something hard. Unable to hold on, for one of his arms had been snapped by the blow, both girls were swept from his grasp. He somehow managed, with his one good arm, to grab hold of a tree as he was swept past it. Climbing to the top and seeing the devastation all around, Bejo wept as the water returned to the sea, causing even more destruction as it went.

Climbing down, he ran to look for his family, but they were nowhere to be found. He hid in the mosque, for Allah had spared the holy places. And that is why he was lucky enough to escape the terrifying second wave, which came thirty minutes later and was even worse than the first.

Many, many, many of our people were not so fortunate. The men told me that Arti's mother and sisters have still not been found and that there is no word of her father, either. But there are so many people in

the hospitals, and no one knows who they all are yet. Many are too ill, or too upset, to give their names. And there are many more wandering around Banda Aceh, or trapped under the broken buildings, or hiding in the hills in case the sea returns. I tell Arti that it is important not to give up hope. We must never give up hope, or we have nothing.

They found Arti the next morning – yesterday morning. She was wandering around, lost in the wreckage of our town. How had she survived the wave after being whipped from her uncle's arms? And what horrors had she seen, poor thing? How had she spent that first, terrible, night?

She was standing alone, watching her bare feet sink into the sodden, stinking soil, when a shadow crossed her path.

'Papa!' she said, looking up. But it was not her Papa. It was a teenage boy, out searching frantically for his family.

The boy knelt in front of her. 'What is your name, little girl?' he asked.

She looked closely at him. Was it her uncle? No, it was not her uncle. This was a stranger. She looked at her feet again. She would not speak to him.

'Please tell me your name,' said the boy. 'I am here to help you.'

And, as her sad brown eyes flitted over his face one more time, and she saw the kindness there, and the sadness too, the fight went out of her.

'I am Arti Stephanus,' she whispered, collapsing into his arms.

'You're boiling!' said the boy, feeling the heat of her skin. And, although his own heart was sore, for this was not the person he had come to find, he carried her to safety.

I wish there was still a school. Like so much else, it has been destroyed by the water. I wish the children who survived, like my Sinta, my Fitri and little Arti, could get up in the morning and go there, just like they did before. I wish there was something, one thing, left in their lives that felt good, that felt normal. But no. I went to look at what had become of it, but there are no desks. No walls. They say the teachers are gone too. They say they will not be coming back.

Everything that was good is gone from here – everything except the holy places – and nothing will ever be the same.

I took Arti up to the camp today, to be with children her own age. But she would not talk. She would not look anyone in the eye. They wanted her

to play, but she would not. Hardly any of them play. So I brought her home again. It is dreadful, walking through the town. I had to shield her nose from the smell. I had to shield her eyes from the bodies, rotting in the sun.

When we got home, I gave Arti a little red apron – they were handing them out at the camp – and I asked her if she would help me cook. She smiled then. A tiny, fleeting, smile but I caught it. She let me tie the apron around her waist. First she watched me and then, in her own time, she climbed up on the stool next to me and began to wash the vegetables, just like I was doing.

I was so pleased! It was the first time little Arti had seemed at ease since she had come into my house. I felt like I must be doing something right at last. Although I knew that it wasn't really about me at all, it was about her mother. This must be something they used to do together. This must remind her of home.

My poor little Arti. I am happy to have you here, my precious child, for as long as you need me, but I know that you will not be happy, not truly happy, until you see your mother or your father again.

I must stop telling you that we will find them, though. I know that this is what you want to hear, but I cannot bring myself to say it anymore, for I cannot believe it, and I do not wish to lie to you. I know your family are gone, as so many are gone, and we, the survivors, must get on with our lives as best we can.

So many have died. So many have been lost. How can we believe that this was meant to be? Oh merciful Allah, give us faith in our time of need.

Arti's happy reunion
A month after the tsunami struck, thanks to Save the Children, the 'real' Arti was reunited with her father. The day before the reunion, Save the Children had released a list of the names of 72 children whom they had registered as separated or unaccompanied at twenty camps across Banda Aceh. 'Arti' was on this list and her name was read out on national radio. Her father came to collect Arti from the Save the Children office and, before she left, the five-year-old girl kissed Sulisna's hand and waved goodbye to her with a big smile.

Fire Stones

EOIN COLFER

I remember thinking *what a beautiful sight*. It was just as Papa had always said, *God is in the water*.

First came the earthquake, then the sea retreated, almost to the horizon it seemed. But now it was coming back.

The wave was high and square with a snowdrift of white foam at its head. It was the biggest wave that I had ever seen, but not so big that I would run away. I had turned thirteen and was not easily scared. The wave would break on the shore, maybe even strand a few bluefin in the sharp grass. I could return home with dinner. Mama would wrap the fish in palm leaves, bake it and serve it with rice cooked in coconut oil. I rubbed my stomach and smiled.

But then I remembered. Mama would not cook. She had returned to the village with a headache. The earthquake had given her a migraine. Tonight, Papa would cook. He would wear the apron and dance around, singing in a high voice. His impersonation of Mama. Actually, he sounded just like her, and we would have to blow our laughter into our hands, so as not to wake my resting mother.

The wave rumbled closer. It made a noise like all the creatures of the world rolled up in a ball. The lion's roar, the bull's bellow, even the snake's hiss. How fabulous. I wished my cousins were here to see it. I considered running to the village to fetch them, but I didn't want to miss the wave breaking. Also, I did not wish to share the fish.

There were more people on the beach. Further down. A group of teenagers were dancing around a radio, slugging coconut toddy from a Pepsi bottle. One had a foot hooked over the side of his canoe, but it was unlikely that he would actually venture into the sea. The Nicobari people respect the ocean and its power.

Something thumped on the sand behind me. Too loud to be a coconut, too soft for a wild pig. I turned reluctantly, not wishing to miss one second in the life of the fabulous wave. There was a boy on the beach. A Shompen boy. One of the ancient tribe that lived in the darkest forest. Papa said that as Christians we should respect every living thing, but even Papa could never summon much respect for the Shompen. They were barely more than cave-people. They were ignorant in the ways of modern life. The Shompen still sacrificed animals, they stole from rubbish tips and they shot arrows at helicopters.

The boy had a swipe of ebony hair hanging over one eye. The other was brown, wide and staring over my shoulder.

'Mountain wave,' he said in a gruff voice. I imagined a talking dog would have a voice like that.

'Are you speaking to me?' I asked.

Shompens were not known for their social skills. Generally they stayed as far away from civilization as the island of Great Nicobar will allow, although in recent years ancient barriers were being worn down and there was even some trading between the Shompens and Nicobari. But this was the first time in my life that a Shompen had addressed me.

I tapped my chest. 'Me? Are you talking to me?'

The boy pointed out to sea. 'First the earth shakes, then the mountain wave comes. We must go.'

The boy spoke Car with a heavy accent. The Shompen have their own ancient language, but no one outside their tribe can speak it. No one can be bothered to try.

'Go,' he repeated, gesturing towards the forest. 'Now.'

My mother had always told me never to follow a Shompen anywhere, especially into the forest. And I did not intend to disobey her. Anyway, I wanted to watch the wave. It was really something when a big wave broke

on the shore, cutting long furroughs into the sand.

I turned my back on the boy. Our conversation was over.

The giant wave made me catch my breath. Suddenly it was close and huge. I hadn't realised how big it must be. Higher than the trees surely. And fast too. It seemed as though the entire ocean was coming this way, not just the surface.

'What?' I said, in surprise, but my own words were smothered by the gigantic rumbling. I felt dwarfed. An ant faced with a descending human foot. But I was being silly. The wave would break on the shore. Waves always did.

I glanced down along the shoreline. The teenagers were not retreating. In fact, they were hooting and hollering, enjoying this fantastic sight.

I felt a hand in my pocket, and it was not my own. A brown arm had snaked in around my waist. The Shompen boy was picking my pocket.

'Hey!' I objected, grabbing at the stick-thin arm. But it was gone, and so was my money pouch, packed with my birthday rupees. The small Shompen boy darted between the palms on the edge of the beach. He would disappear now, I knew it, and I would never catch him. The Shompen were like ghosts in the jungle. They were harder to spot than a crocodile in a drift of logs.

But for some reason, the boy stopped. He turned and waved my pouch at me. A taunt that no thirteen-year-old boy could resist. That little thief may have been Shompen, but my legs were fast and I had the strength of the wronged behind me. I forgot the wave and ran.

It was quite a chase. I could run, but the Shompen boy could read the jungle like an open book. Every dip in the sandy clay, and every root that snaked from the earth to trip us, seemed to be a part of his plan. A quiver of arrows clattered on his belt as he ran, and I noticed a short bow across his belt. He wouldn't shoot me. Surely not. I almost called off the chase, but the boy seemed to sense my reluctance and waved my pouch over his head like a trophy. My brow burned, and I sucked a deep breath, sending the oxygen to my muscles.

Faster, I told myself. *You are the taller boy. You will snap his arrows across his own legs.*

So, for five seconds I ran faster, then the world changed forever. My ears were filled with the sound of my blood boiling, or so I thought. But the

sound grew loud, filling the air, drowning out the insects. It was the wave, howling towards the shore.

I ran on, because I was already running. And maybe because something deep inside me knew already that this wave was not just slightly out of the ordinary. I looked to my right, through a picket fence of palms, to where the other boys stood, dancing like monkeys. Jeering the water.

I think that was the moment I knew for sure. I saw this wave, not like a swimmer's arm, curling up and over, but like a fighter's arm with a fist at its head.

The fist slammed into the boys, burying them instantly. There was no struggle or cry. Just alive, and then dead. I cried out, still running. Tears flooded my eyes, but I kept running. The Shompen boy sprinted ahead, barefoot, reading the ground. I followed. Mother had always said, *never follow a Shompen*, but I was thirteen now, able to make up my own mind.

Spray from the wave spattered my neck. Stones too. It was sending out messages. *I am coming for you, little boy. Your little legs are not strong enough to outrun me.*

There was a hill ahead. Small and rough, dotted with neem trees like arrows in a pig's back. The money thief ran towards the summit. So did I.

There was foam at my ankles. Noise buffeting me like a giant wind. Sticks flashed past, spearing the earth. Fish flapped on the ground. Wide-eyed and amazed.

Water now. Up to my knees. Fresh and salty. Not clear though. Thick with mud. The Shompen scaled a giant tree, right at the summit. He went up like an animal, fast and sure-footed. I tried to follow, tried to copy, but I am no Shompen. Our tribe have forgotten how to live in the trees. My feet slipped on the rough bark, my fingernails tore and bled.

Crying, I turned to face the water and was amazed at the ruin behind me. The wave had all but eaten the coastline and was flowing on towards the village. It was trying to scale the hill too, rolling its way towards me.

The wave would make it, I thought. It would flick up a finger and dislodge me from my perch. Then on to my village. Maybe the entire island. What was happening to the Earth? Was this the judgement day the Bible spoke of?

Then, to my relief I saw that the wave was dipping. My feet were clear of the water. For several seconds, I sobbed in selfish relief, before I realised that my family were probably not so lucky.

This brought on a second round of sobs. I ran to the water's edge and peered towards our village. But there was nothing but water, its surface almost solid with smashed dwellings. For several minutes, I hopped on the hill with frustration. I must have looked like a monkey.

I calmed down momentarily, but then my panic returned. Oh my God. There was a second wave behind the first. Crouched on its back. Six feet higher, high enough to snatch me off my little hill. I scrabbled at the tree trunk again, but it was slick and gave me no purchase. Corkscrew thorns wormed into my forearms.

I turned to face my doom. I saw people in the water. And houses. And a shark. I swear I saw a shark snapping at the sea, its new enemy. An enemy that had always been its friend. The shark, mouth open wide, saw me, its last meal.

Then I was snatched, from above. The Shompen boy had me by the shoulders, hauling me into the neem tree. My sandals were ripped away by the wave. One found its way into the shark's mouth. I don't know how I saw that. It should have been impossible. But somehow, for a fraction of a second, the water was like glass and I saw the shark slide below me. A torpedo of steel-blue muscle.

Then I was in the branches. Cowering behind a sheet of leaves, as if they could shield me from anything. What did it matter? The wave would surely uproot the tree. We would both be dead in a few seconds.

The Shompen boy squatted beside me, apparently calm. His eyes were wide, but his body was relaxed and casual. He knew that there was nothing more to do. Whatever happened was beyond our control.

What happened was that we survived. The wave flowed inland for what seemed like an eternity, but it never managed to uproot our ancient tree. The hill became a little island on the back of our sunken island, and the Shompen boy and I were the only two inhabitants.

Things flowed beneath us that nobody should ever see. The sea had claimed its bounty, and now it was revealing it to me. Shacks, bicycles, livestock, and

of course people. My heart was torn from my chest as I saw a girl I knew float past, her beautiful dark hair trailing behind her. I think she was a distant cousin. She was encased in driftwood and rubbish, like something lost and worthless. I will never forget that image. I have thought about her so much since that day that I feel she is known to me now. Much more than in life.

A sharp pain in my arm cut through the dull pain of despair. I looked down. The Shompen boy was twisting a corkscrew thorn from my forearm. I jerked away, then pulled at the thorn myself, but the boy gripped my hand firmly.

'Not pull,' he said, in his thick accent. 'Turn. Pull makes a big hole.'

He gripped the thorn again, twisting it gently so that it followed its own path out. The tip was covered with half an inch of my blood. I almost felt sorry for myself, but then I remembered that I was alive to feel pain. My distant cousin was not. And what of my family? Mama and Papa. My God, what of them?

I wanted to jump down from our tree and run to the village. But all I could see were treetops and water. The wave still covered the ground and it was moving in fast muscular currents. If my parents were alive, they would not want me to kill myself. So I was stuck here for the time being, at the mercy of a pickpocket Shompen savage.

A savage who had saved my life, and fixed my arm.

I looked closely at the boy. He seemed friendly enough, but he was a thief. I couldn't trust him. Maybe he had saved me so that he could ransom me off later. If there was anyone to ransom me to.

'Why are you here?' I asked him.

The boy shrugged. 'I was leaving with the others, for the high ground. Then I saw you walking towards the water.' He slapped the side of his own head incredulously. '*Towards* the water. Everyone knows that after the earthquake comes the mountain wave.'

I nodded, as if I too had known. As if any of the Nicobari had known. Maybe the Shompen were not as stupid as we thought.

'So, your family are safe?'

'Yes. High ground. Father will be angry with me. Stuck in a tree with a

Nicobarese.'

'That's what you get for trying to rob an easy target. I suppose you thought the wave would drown me, and there would be no witnesses to your theft.'

The Shompen boy frowned. 'Target?'

'Yes, target. Someone to steal from.'

'Steal?' spat the boy, as though that had not been his purpose. 'You are stupid, Nicobarese. Stupid, like my father says. I should have saved a pig instead of you.'

And with that, he crawled to the end of a long branch, hiding in the foliage, leaving me to twist out the other thorns in my flesh.

Hours passed and still the water stayed, rolling about the trunk like a nest of giant snakes, waiting to snatch anyone foolish enough to venture down. I stayed where I was.

Miserable. I was cold, wet and hungry, but more than that I was feeling a terrible anguish. People were dead, that much was certain. But how many, I could not know.

I did know that my life had changed forever. This was a new world, a terrifying one. One that could end at any moment.

I could see nothing beyond the water. But sometimes I heard voices. In the distance, women were crying. That could be my own mother, crying for me. She must believe that I was dead, just as I thought she was.

Sometimes, people floated past our perch, clinging to anything that would float. In every pair of eyes was a blank look of shock. How could the Earth turn on us so quickly, and with such venom. As if we were responsible for the crimes of humankind. Our helpless little island.

I heard a rustle in the branches and looked up to see the Shompen boy approaching. His face was serious and he had an arrow notched in his bow. The arrow was aimed at me.

'Quiet, Nicobarese,' he whispered. 'No moving.'

I did not move, though I was tempted to throw myself into the water. So the thief had graduated to murder. Papa had told me that the Shompen

have no regard for human life outside their own tribe, so I suppose that I shouldn't have been surprised.

The Shompen boy drew the arrow close to his cheek, then fired. The arrow sped over my shoulder and into the leaves behind me. There was a long string tied to the arrow and the Shompen pulled at the other end. A half-dead chicken squawked feebly as it was yanked from its perch. It was wounded only through its wing, but the Shompen boy quickly finished it off with an efficient twist of its neck.

'Food,' he said, smiling.

I felt bad. I had suspected this boy of murderous intent, but now I saw that he had simply been trying to feed us. Hopefully us, not just him.

The Shompen removed his arrow and tossed the limp fowl to me.

'Feathers,' he said, making plucking motions.

I was glad to pluck the chicken. This was something I knew how to do and it would take my mind off my surroundings. I almost felt sorry for the chicken. Imagine somehow flapping your way out of that wave, then landing on the only tree on the island with an armed boy in it. Bad luck indeed. I gripped a handful of breast feathers and pulled.

As I plucked, the Shompen boy took up his knife and carved a hole in one of the branches. He filled the hole with the driest kindling he could find, then took two black stones from his belt and began cracking them together. Each crack produced a spark, and eventually, amazingly, one of these sparks actually caught. He fed the flame, blowing gently into the carved bowl. In minutes, a small but bright fire sent a thick stream of black smoke skywards. I felt its glorious heat on my face and the silent mosquitoes backed away from the smell.

'Amazing,' I said. And I meant it. I had never seen stones like that. To start a fire in the middle of a humid jungle was a great skill indeed. But to start a fire while stranded up a tree and surrounded by churning floodwaters was amazing.

The boy smiled again, our earlier disagreement forgotten. He frowned then, trying to think of the Car words for his precious stones.

'Fire stones,' he settled on eventually, sparking the stones together. 'Very valuable.'

I nodded and even smiled, trying to send the message that I respected and was grateful for what the Shompen boy was doing. He may be a thief, but he had saved me and was now feeding me. I was prepared to forget about the money-snatching.

We cooked the chicken on a spit, picking off bits as soon as they were done. This was a real treat. Generally we saved chicken for special feasts. This fowl probably came from somebody's coop, but in the circumstances, this thought did not cause me any guilt.

The Shompen boy tossed the carcass into the water.

'For the shark that missed you,' he said.

'Thank you,' I said. It was all I could think of to say. There was no point in us communicating really. If it hadn't been for the wave, then we would never have shared anything except distrust, and when we got down from this tree, we would never speak again. This was the way things were. I was starting to think that this was a great shame. No matter what Papa said.

'Hey, you two!' said a voice below us. I looked down. There were two men in a canoe, paddling against the current. I recognised one, a Nicobarese from a nearby village.

'We saw the smoke. How did you manage to build a fire in that tree? It's wetter than my paddle.'

Then he saw the Shompen boy.

'Ah, I see. A little jungle magic. Anyway, climb down. This tree is not going to last long.'

The Shompen boy considered the offer, then leaped from the tree, landing neatly in the canoe. It took me a while longer, feeling my way down the trunk, wary of corkscrew thorns. The man's hands grabbed me under the armpits when I came within arm's reach.

'Are you hurt?' he asked, plonking me on the upturned crate that acted as a seat.

'No. Just a few thorns.'

'You are blessed. To have survived this near to the coast. We haven't found anyone else. Alive, that is.'

'My village beyond the ridge. Was it destroyed?'

The man frowned. 'All the villages were hit. Most were destroyed completely. But many people made it to higher ground. There is hope.'

A strange numbness settled over me. I did not want to face the horror to come. I shut my mind to the terrible sights all around me. If I was to preserve hope then I could not afford to see all this despair.

The canoe came within ten metres of the shore and suddenly the Shompen boy was on his feet.

'Hey,' said the second man. 'Sit down, Shompen idiot.'

'Don't call him that,' I blurted, surprised to find myself defending a Shompen. 'He saved me.'

The Shompen boy jumped onto the rim of the canoe, then stepped off, into the water. Or so I thought. I saw then that he had landed on a floating tree trunk. He ran along it to the shore. Then he turned to look back at me. It was the last time I would see him. His last act before disappearing into the jungle was to pat his thigh, right where a pocket would be.

I automatically patted my own thigh. It was heavy with my money pouch. The Shompen boy had somehow put it back, without my feeling a thing. I pulled it out and of course all the money was there. And there was something else in it. Two black stones. The Shompen boy had made me a gift of his precious fire stones.

I almost cried at my own stupidity. The theft had been a ruse to make me follow the Shompen boy into the jungle. I had refused to come when he had simply asked, so desperate measures had been required. He had risked his own life, saved mine and fed me. And all I had done in return was call him a thief.

I felt more ashamed at that moment than any time before or since. I knew then that the Shompen boy was a better person than I. All this, and we didn't even know each other's names.

He would have his fire stones back, I decided, pocketing the pouch. When this was all over, I would find him and thank him properly, even if I had to scour the jungle on my own. Papa wouldn't like that.

And then I began to cry in earnest, the sobs shaking my shoulders. Maybe Papa wouldn't be around to disapprove.

The man behind me misinterpreted my tears.

'Don't worry, son,' he said, patting my shoulder. 'You're safe from that Shompen savage now.'

I didn't correct him. I didn't have the right. Only this morning, I had thought the same thing myself.

Helping the people of the Andaman and Nicobar Islands
Some of the Andaman and Nicobar Islands are strictly off-limits to foreigners in order to protect the Shompen and other aboriginal tribes from outside influences. The Shompen number less than 400 and are near extinction. Living deep in the forests, they were one of the tribal groups barely touched by the tsunami. In contrast, the Nicobari tribe, who live in their thousands on the coast, lost more than 5,000 members. Y Care International was one of a few charities able to help the people of the Andaman and Nicobar Islands, through its local partner YMCA based in the islands' capital, Port Blair. In the aftermath of the tsunami, Port Blair YMCA worked with local communities to distribute essential food parcels, clothes and medical aid. It is now working to repair damaged houses and provide educational support for children affected by the disaster.

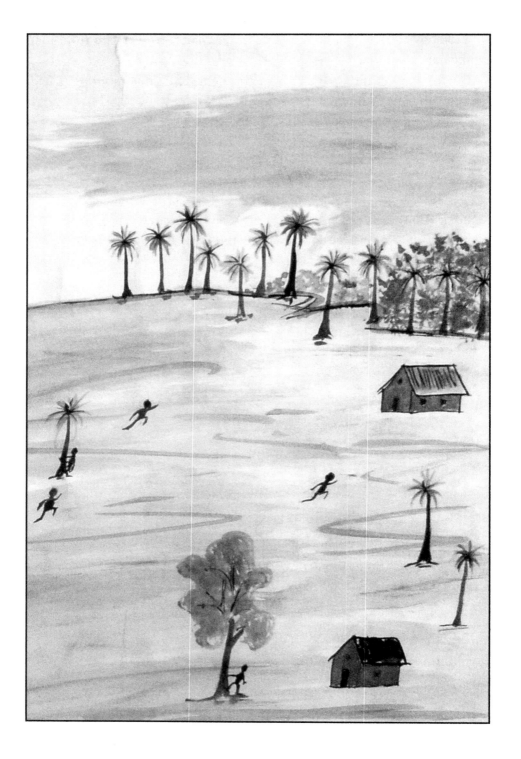

Aung-San

Elizabeth Arnold

Aung-San saw the waiter rushing angrily towards him, flapping an empty tray. Instinctively he cowered, covering his deformed mouth and nose with cupped hands.

'Take that little monster away from my restaurant.' The waiter yelled at his mother and older sister. 'I don't want my customers put off their food.'

Aung-San's mother ignored him. She offered Aung-San his ice-cream and waited patiently until he found the courage to move a small hand to take his special treat.

'I said, take him away! He's enough to put anybody off eating and I don't want to see you here either. You Burmese immigrants seem to think you can just march in and take over the world.'

'You're upsetting your customers,' Aung-San's mother replied calmly. She turned to a group of gathering Thais. 'Did you see that?' she asked. 'How could you think of eating here when this man is so cruel?' Just as she'd hoped, they turned away, not wanting trouble.

The waiter was enraged. He kicked at the yellow sand, sending it everywhere. 'Why are you going?' he shouted at the departing group. 'They're Burmese! They work for peanuts. They steal our jobs...'

Aung-San lost his nerve. He dropped his ice-cream, even though he'd had only two mouthfuls, and ran as fast as he could towards the sea. He wanted to run in and drown. He wanted the waves to take him so he could be with his lost brother and sister. He longed to be a different person, someone in another place, another time.

'Aung-San! Stop!'

Aung-San ran away from his mother and past his older sister. He stopped just short of the gently lapping waves. The events of that terrible day, less than a week ago, came rushing back. Fear stopped him from entering the water. Fear that was greater than his desperation. Fear that was as black and bottomless as death itself.

'Aung-San!'

Aung-San turned to face his mother.

'Somehow we'll start again. One day you *will* have a new face, precious one,' she promised. 'Oh, Aung-San, believe me, please.'

Aung-San's mother smiled brightly, but he wasn't fooled. He could see her fighting back tears. His life was hard enough even before the tragedy of last week had happened. He felt he'd already suffered too much. Barely a day went by when he wasn't taunted or teased, and his mouth hurt. His mouth *always* hurt. It wasn't fun having a cleft palate. It wasn't fun knowing everybody thought you were ugly with your split nose and hole of a mouth, with your twisted lips and funny teeth. Not feeling human was no fun at all.

Aung-San turned his face towards the sea. He thought about his lost brother and sister. Then, feeling ashamed, he thought about his lost pigs. The pigs that could have made him better.

'Aung-San, come sit with us.'

Aung-San walked back to his mother and sister. He climbed onto his mother's lap and for a long time they sat quietly on the sand. The night was heavy and humid, but a cool breath of air from the gentle ocean blew out the worse of it. Even though the waiter had been so nasty, Aung-San was glad he had come.

It was his sister who'd suggested they return. 'I need to go back,' she'd said that morning, filling a basket with marigolds. 'I need to say a proper goodbye before the New Year.'

'Good idea,' Aung-San's mother had agreed. 'As we watch the dawn break we can wish new hope for everybody.'

It was New Year's Eve, but there would be no fireworks that night. No celebrating, no drunken revelling tourists. There would be none of the usual giving and receiving of presents either. People had simply gathered on the

beach as if summoned by the dead. They stood in small groups, holding glowing candles or single white roses. Their tears had been silent, their thoughts subdued as they waited for dawn. In that precious and somehow magic moment, they stood together, united in the aftermath of a force greater than all of them. It wasn't difficult to remember what had happened. The beach was still littered with fallen trees, bits of houses and pieces of broken fishing boats. Aung-San shivered as he spotted a small sandy shoe. He glanced away, at their little basket full of marigolds waiting to be scattered into the water.

* * *

The waters had been calm when Aung-San was last here, almost a week before. He remembered the ball. Some tourist must have left it behind. It was red-and-white and still full of air. He and his brother and sisters played with it for ages. Then his older sister grew bored and went back up the beach to sit with their mother. That's when the first odd thing happened.

'Wow, Aung-San, look at that!'

Aung-San turned and stared in amazement. The sea was retreating. It was rushing back towards the horizon at high speed, leaving vast tracts of gleaming sand. Never had the sea gone back so far before.

The delighted children raced down the beach, following the retreating wave as fast as they could. They tried to catch up with it but it was far too fast. Back and back it went. Suddenly distracted, they stopped running. 'Look! Look at the fish on the sand!' Aung-San stared at the small fish that had been left exposed. They danced beneath the sun in a desperate attempt to return to the water. The children began to run backwards and forwards, trying to catch the glittering fish. 'The biggest ones are the furthest out,' Aung-San's brother yelled, rushing towards the still-receding water.

Aung-San ran after his brother and sister but he was by far the slowest. 'Wait for me!' he called. 'Wait for me!' His brother and sister ignored him. They were far too busy racing to find the biggest and best fish to take home to Papa. They didn't even hear his cries. That's when the first big wave came. It rushed towards the shore, making a huge roaring sound, and the closer it

got, the larger it grew. Terrified, Aung-San froze.

Suddenly Aung-San felt his mother dragging him away from the water. 'Run!' she shouted. 'Run up the beach to your big sister. Run as fast as you can.'

His mother headed on towards his brother and younger sister, Aung-San ran back as fast as his legs would carry him. Just as he was about to collapse, his older sister grabbed his arm and began dragging him even further away. 'Don't stop! Come on, Aung-San. Keep running.' Only when she was sure they were safe did she let Aung-San rest. Together they looked towards the ocean, hoping to see their mother, brother and sister.

Everything was in chaos. The water seemed to be boiling. Trees, cars and boats bounced about like beans in a pot. People were running and shouting and screaming. And those who did not flee fast enough were dying.

Neither of them saw their mother desperately trying to reach their brother and sister as the first wave retreated, dragging the children even further out and sucking them under. They spotted her only when, wet, and exhausted, she returned, alone. Aung-San would never forget the look on her face. The total despair in her wide brown eyes.

Together, in disbelief, they watched the second wave rushing towards them. It was so big and black it seemed to wipe out the sky. Buildings and trees collapsed in its path. The noise was incredible. Aung-San felt his mother's grip on his arm as she dragged them further and further inland. One part of him wanted to run on forever, another part wanted to stop and watch what was happening.

Hours later, when the sea had calmed, Aung-San's Papa joined them as they searched desperately for the bodies of their missing children. 'If only I'd been here,' he kept saying. 'I didn't see them enough and now they are gone.'

He sat down, his head between his hands. 'What use am I now, with my livelihood gone, my boat smashed to splinters? How will I care for you all?'

Aung-San's mother tried to be reassuring but her look was tired. 'You'll find something to do. At least you're alive.'

They had searched for ages. On the beach, among the wrecked buildings, in the makeshift morgues and even in the branches of the few trees that remained standing. It was hopeless. They found nothing. There were so many dead. Eventually they gave up, knowing the children were gone forever.

*　　　*　　　*

Aung-San sighed. Sometimes that awful day seemed like a million years ago, and sometimes like yesterday.

People *had* tried to help each other in the aftermath of the tsunami, but even though they'd been in Thailand for ages, Aung-San's family, being immigrants, were treated as second-class citizens. Somehow they always missed out, always came second, even with emergency food and water. 'I'm Thai, I was born here.' Aung-San tried to say, but his words were unclear. Somehow, they still ended up at the back of the queue.

'Don't worry!' Aung-San's mother had said, holding her head high. 'We are Burmese. We can take care of ourselves as we've always done. We'll manage.'

Aung-San remembered his mother's words. He didn't want to just 'manage'. It wasn't enough. He ran his finger along his upper lip, along the break in the middle that split it in two. He felt the skin curl inwards. He fingered his teeth that stuck out at awkward angles. As usual, his mouth was painful.

If he still had his pigs, things would be better. It had taken ages to save up for ten piglets and to make them grow big and strong. 'They're your pigs,' his mother had said. 'When we sell them, you can have an operation to mend your mouth. You must look after them very carefully.' Aung-San had done everything his mother had asked. Everything and more. But now the pigs were gone.

Aung-San buried his face in his mother's lap and sobbed. His mother gently stroked his head. His troubled breathing fell into the restful pattern of her caress. Slowly he calmed. They were here to remember his lost brother and sister. He tried hard not to think of his pigs, but it was impossible. The image of their bloated bodies, washed up on the beach, still haunted him. Why did *they* die? He couldn't understand it. Most other animals had survived.

'Mama, Kulap told me that her dog disappeared on the morning of the tsunami. It didn't return until everything was over. And Ratsami, you know – the man who sometimes gave me old vegetables for my pigs – he told me

that his life was saved by his elephant. He said it wouldn't budge when it was time to go down to the beach to wait for the tourists. It refused, even though he asked nicely, even though he got so cross he beat it with a stick, something he's never ever done before. He says that the elephant was smarter than him. Somehow it knew something awful would happen. Now he feeds it the best bananas while he waits for the tourists to come back.' Aung-San looked up at his mother. 'Why didn't our pigs escape?'

Aung-San's mother sighed. 'The pigs' fence was too strong. Even if they'd wanted to run away, they couldn't. When we saw that retreating wave, we didn't understand the danger, did we? How could the pigs have done?'

They sat in silence for a while. The sad sound of singing interrupted their thoughts. Some fishermen were returning to shore in their tiny boats. Aung-San felt the familiar wave of injustice and despair rise within him. 'Why did Papa's boat get taken? Why did we have to lose *everything*?' he wailed.

'We didn't,' Aung-San's mother replied quietly. 'You still have Papa and me. We were lucky he was sick and stayed home that day. You have a big sister and soon you'll have a new baby brother or sister to love,' she said, rubbing her belly. 'Look at all these people! Lots of them lost whole families. *Everyone gone.* Imagine that! It's not so bad Aung-San. Try to think that your brother and sister have been released from the burden of life.'

Aung-San did think that, often, and often he envied them. In Buddhism – the religion of the Thai people – funerals were considered happy occasions, celebrating the liberation of the soul. His mother was usually less convinced. 'We're not Thai!' she often told him. Aung-San thought of the small sandy shoe, and he wasn't convinced either. Too many souls 'liberated', most of them small. Why, why, why?

Aung-San tried hard to think positively. He thought about how quickly the tourist stalls had reappeared. You could still buy glass eggs and shiny beads, brightly knitted hats and beautifully woven jackets. The fruit and vegetable stalls were back too. On the surface, everyone seemed to be doing what they did before. There were only a few tourists, but they, the traders, worked on. They had to – almost as if that was the only way to bring back some order into their disrupted lives.

Aung-San thought about Phara, the wood carver who used to live near

them. His stall hadn't reappeared. Phara used to be so happy working on his reliefs and Aung-San liked to sit next to him and watch as a busy market scene, a magnificent temple or a beautiful jungle, alive with birds and monkeys, orchids and elephants, emerged from a plain piece of wood. Phara would sometimes work for a year or more on just one picture.

Everyone used to joke about Phara being attached to his chisel and Aung-San was sure that he had held onto it until the very last moment, until the sea took him. Yesterday, Aung-San had found a small carved relief floating among the wreckage. He intended to keep it forever. Phara had never seemed to notice his mouth. He had always been patient, willing to listen. He had been his very best friend.

The stall of another friend still remained. Just that morning, Aung-San had spotted Sarai, brown eyes twinkling, as she peered out at him from beneath her big straw hat, ready to offer him a banana or coconut, just as she always had. Now he realised that like her, he'd have to be brave and begin his life again.

Aung-San sat upright. Thinking of Phara and Sarai had somehow buried his anger. They had given him love even though he was ugly. And they weren't family and they weren't Burmese. He *was* alive and maybe, when he was grown, he could be a woodcarver like Phara.

* * *

The night sky was beginning to lighten and soon it would be a new day, a new year. Aung-San climbed down from his mother's lap and walked slowly to the water's edge. The shallow sea was awash with marigolds. They danced brightly on the water, telling him he wasn't alone and others suffered too. He could hear people sharing memories, reliving the good times. He thought of his brother and sister. He could still hear their laughter as they ran backwards and forwards with the brightly coloured ball. *That's* what he should be doing, remembering the things they had shared. The love given and taken – that was much more important than pigs and a scrunched-up face. There was no need for bitterness or anger.

Aung-San realised that those he had loved and lost would never really

leave him. He would see them in his mind and in his heart, in the falling dusk or, as now, in the rising dawn. He reached out for them, knowing they would soon fade from sight but never from memory. He could see them, clear as day, Phara and his brother were greeting him, palms together, head bowed, in the respectful *wai* salute of arrival and departure. Aung-San returned the gesture. His sister was there too, smiling. She was always smiling, always happy. Aung-San grew more confident. They were telling him that it was time to move on.

Aung-San looked back towards his mother and sister. They smiled, knowing that, like them, he'd walked through death to find life. Hand-in-hand, they walked among the crowds of people on the beach. It didn't matter if they were Thai or Burmese. What mattered was that it was New Year's Day and flowers were scattered, memories made. Everyone was united in grief and struggling to see the future. It was time to acknowledge the past and look forwards the best they could.

Aung-San smiled at his mother and sister as he reached out and took a huge handful of marigolds. 'I shall never forget them,' he promised, scattering the flowers onto the gently lapping water. 'Never!'

Aung-San's struggle continues

In a country where a disfigurement or disability can be seen as a curse from God, Handicap International has been working with communities in Thailand to educate people about the real causes. In this way, it is possible to help prevent child abuse, exploitation and to encourage support for children like the 'real' Aung-San. Unfortunately for 'Aung-San' though, he has still had no treatment for his facial disfigurement – and he faces further discrimination from the community for being a Burmese immigrant. His mother has said that an operation would cost more than 60,000 bahts (£800), but they earn only 10,000 bahts a year. But with the support of charities such as Handicap International, they are determined to find a solution to help 'Aung-San' smile.

AUNG-SAN

Colours

NARINDER DHAMI

Aaliya stared down at the large sheet of paper on the desk in front of her. The paper was clean and square and white, inviting her to cover it with pictures.

'Draw whatever you feel like drawing,' said the kind lady, who was standing at the front of the classroom, watching the children. But there was only one thing Aaliya could think about. The Black Day. She sat there quite still. She didn't reach out for the coloured pencils that lay in front of her.

Yesterday, a boat had come across the water from Male, the capital of the Maldives, to the island school, bringing crayons, pencils and drawing books, skipping-ropes, footballs and bright, striped hula hoops. Aaliya could hear the shouts of the older children out in the playground. She wished she was with them. She wished she was anywhere but here.

There were eight pencils lined up on her desk. They were new, with neat, sharp, coloured tips. Aaliya had always loved to draw. Once, her bedroom walls had been covered with her drawings, bursting with joyful colours. Now, of course, the drawings were gone, and they had taken her love of colour with them.

Aaliya pushed aside her favourite pink and green pencils. Those colours had no part in her world now. The only colours roaring inside her head were purple, blue, red and black. What shall I draw? she asked herself. But she already knew the answer to her own question.

Aaliya picked up the black pencil. Immediately she was gripped by a fear so cold, so huge, that for a few seconds she could do nothing. Then, at last,

she bent her head over the paper.

The Black Day had started like any other Sunday morning. The sky was blue, the sea was bluer, the sun a fiery yellow ball in the sky. The weather hardly changed in the Maldives. Sometimes there were heavy showers of rain, but Aaliya didn't mind that. The rain left the island fresh and green. She had never seen snow, except in a picture book.

'Aaliya.' Aaliya could still hear her mother's voice clearly inside her head, as the black pencil hovered over the white paper. And in her mind, she could see her mother's pink shalwar kameez, her older sister Sara's orange T-shirt, her father's green shirt. 'We're going to the market. Do you want to come?'

No, Aaliya didn't want to go. They went to the market every Sunday morning to buy tuna-fish and vegetables – it was nothing special. Today Aaliya wanted to stay in her bedroom and draw.

'We'll have breakfast when we get back,' her mother told her. 'Be good!'

The classroom was cool, the fan purring softly overhead. Aaliya put her finger on the paper, a third of the way down from the top. Then, carefully, she drew a thick black line from her finger to the other side of the paper. This was the line where the sea met the sky.

'Bye, Mama. Bye, Papa.'

Aaliya tried not to think about her parents and Sara leaving the house for market that Black Day. They had been laughing and talking. She could hear their voices in her dreams. If she'd known what was going to happen, would she have said something more? She hadn't even said goodbye to Sara. Would she have gone with them? Or would she have stayed at home?

When they'd gone, Aaliya had sat cross-legged on her bed, a blue colouring-pencil in her hand. I'll draw a picture of the sea, she had thought. From the window of their coral-stone house, she could see the water in the distance. In the Maldives, with its hundreds of islands, you were never far away from the sea. Aaliya had grown up with water all around her. She wasn't afraid of it. She never even thought about it. It was just there.

Aaliya clutched the black pencil tighter. Now she realised that sitting on her bed that Sunday morning was the last time she had felt happy. The very last time her world had been full of shining colours.

Aaliya felt her throat closing up as if she couldn't breathe. Pressing the black pencil to the paper once more, she drew the outline of a house. A one-storey, coral-stone house with a rusty red iron roof. But she drew it below the black line, in the sea, under the water.

'I'm hungry…'

Aaliya remembered the empty, rumbling feeling in her tummy, as she sat on the bed, adding the finishing touches to her picture. The sky and sea were deep blue, birds above and fish below. There were fishing boats on the water and seaplanes in the sky. Palm trees and coral-stone houses. The picture was almost finished. All Aaliya had to do was add herself and her family in front of their house.

As Aaliya began to draw her father, she was hoping that they would have *mas huni*, her favourite breakfast of tuna-fish, onion, coconut and chilli with bread and tea. Where were her parents and Sara? They seemed to have been gone for hours.

And then Aaliya heard it. The first sound of Black Day. The screaming.

Now, her head bent over the paper on her desk. Aaliya couldn't stop the tears from pouring silently down her face. She began to draw. Boats, seaplanes, houses, palm trees. But now they were all under the sea, swallowed greedily by the water. Suddenly Aaliya's hand seemed to be working by itself, almost as if she could go on drawing for ever and ever without thinking about it.

The loud screaming had brought Aaliya to her bedroom window to find out what was happening. The first thing she saw was people running in all directions. For a split-second, she couldn't understand why. But, almost at the same moment, she realised that they were running from a solid wall of water. It towered above everything, taller than the houses, taller than the trees.

'No,' Aaliya had whispered to herself, shock freezing her limbs. It couldn't be possible. The sea and the land had their own space. The water didn't belong here.

Pictures imprinted themselves on Aaliya's mind in those few brief seconds, pictures she would never be able to erase. Some people had already climbed up onto the roofs of their houses. Others were clinging to palm trees, trying to stop themselves from being swept away. There were men and women and children in the water, being tossed and hurled this way and that, calling for help. Aaliya knew she would never forget the identical look of terror on all their faces. And still the menacing wall of water swept ruthlessly on its way, straight towards Aaliya's house.

'It's coming for me,' Aaliya gasped. 'Help, Papa!'

There was no one to help. Aaliya ran towards the front door, but before she could open it and escape, there was an ear-splitting crash as the wave lunged towards the house. It smacked against the door, battering it mercilessly, trying to force its way inside.

Aaliya didn't know if the roaring in her ears was the *thump thump thump* of the monstrous wave against the frail front door, or the wild pounding of her heart in her ears. As water began to seep menacingly underneath the door and into the house, her whole body was gripped with a terrible, black fear. She ran into her bedroom and slammed the door.

She was trapped...

Aaliya put down the black pencil and picked up a red one. Other children in the classroom were crying, but she didn't hear them. She was sobbing too much. Tears dropped onto the paper as Aaliya drew two stick figures, one tall, one smaller, half above and half under the sea. She coloured the top half of both figures red, but left the bottom halves, which were under the water, uncoloured, lifeless.

The water continued to swell under the front door. From her bedroom window, Aaliya could see waves rushing past, carrying away people, trees and cars as if they were toys and weighed nothing at all. Aaliya could hardly bear the noise – the roaring water and the screams, and the sound of houses

collapsing and of trees being torn up by their roots.

Suddenly a red mist danced in front of Aaliya's eyes.

'Mama!' she shouted. 'Sara!'

Her words were snatched away by the tumbling torrents of water. Aaliya had seen her mother, unmistakeable in her bright clothes, floating past the window. She had her arms wrapped tightly around Sara. Their eyes were closed and neither of them were moving. There was no sign of Aaliya's father...

Aaliya gulped, trying to swallow her sobs. She changed the red pencil for the black again, and, gripping it tightly, began to colour in the sea under the line and around the drowned objects. As the water grew blacker and blacker, Aaliya felt her anger and hatred of the sea rise and swell, just as the water had risen and swollen inside her home on that Black Day...

Soon the water had started battering at her bedroom door, seeping then pouring underneath it and into the room. Terrified, tears streaming down her face, Aaliya had crouched on her bed. She had nowhere to go and no one to help her.

The water level rose higher. Soon the bed lifted off the floor, taking Aaliya with it. She watched as the water tore her pictures from the walls, turning them into a soggy, floating mess. Suddenly, and strangely, Aaliya began to feel calmer. As the bed rose higher, the waves tossing and buffeting it around the room, she lay back and closed her eyes, just like Sara and her mother. The water was so high now it was lapping over the top of the bed, washing over her shoulders.

'Mama,' Aaliya whispered. 'I'm coming to you.'

Aaliya didn't know how long she lay there soaked through, eyes closed, waiting for the water to carry her away. It could have been minutes; it might have been hours. At first she didn't know that the water, a wave bigger than any building on her island, bigger than any wave she'd ever seen before, was washing away, back into the sea. Then, at last, as the bed floated back down to the floor, she realised. The sea had rushed away, back to its rightful place beyond the land. And she was alive.

Aaliya had coloured in the sea so hard and so fiercely that not a speck of white paper could be seen underneath the line. But still she continued to make the black thicker and thicker.

Leaving the house that day, unable to understand what had happened on her island right in front of her, it was as if all five of her senses were dazed and confused. Outside there was a sickening smell of sodden, drowned bodies and the dead fish that littered the streets. Aaliya could taste the thick humid dust that hung in the air, making her eyes water. After the roaring of the water, there was an eerie silence, broken only by the sound of people crying. And Aaliya simply couldn't make sense of what she was seeing. Streets of houses had been flattened into rubble. Trees had been swept aside. Most of what had stood upright was now destroyed and devastated. Desperate and alone, Aaliya had longed to feel her mother's touch...

Aaliya stared down at her picture of the Black Day. She hadn't seen her father since that morning. Her uncles were still searching for him. Suddenly she pressed the black pencil so hard against the paper, the tip broke off and the paper ripped from side to side. The sound echoed through the classroom.

'Aaliya?' The kind lady who had brought the pencils and paper to the school came over to her. She had a gentle voice. 'Don't you want to colour the sun in the sky?'

'No,' Aaliya replied flatly, pushing the brightly coloured pencils away. 'There was no yellow that day.'

Art therapy in the Maldives
Creating art and playing with others are essential activities that help children release buried pain and grief. In the days immediately after the tsunami, UNICEF provided 116 primary and secondary schools in the Maldives with 'school-in-a-box' kits, containing crayons, paints and drawing pads, for 16,000 children – each of them just like 'Aaliya'. UNICEF also distributed recreation kits, containing footballs, frisbees, skipping ropes and hula-hoops for 24,000 children. Because of this aid, all children were back in school only two weeks after the normal start date for the New Year – painting, playing and healing.

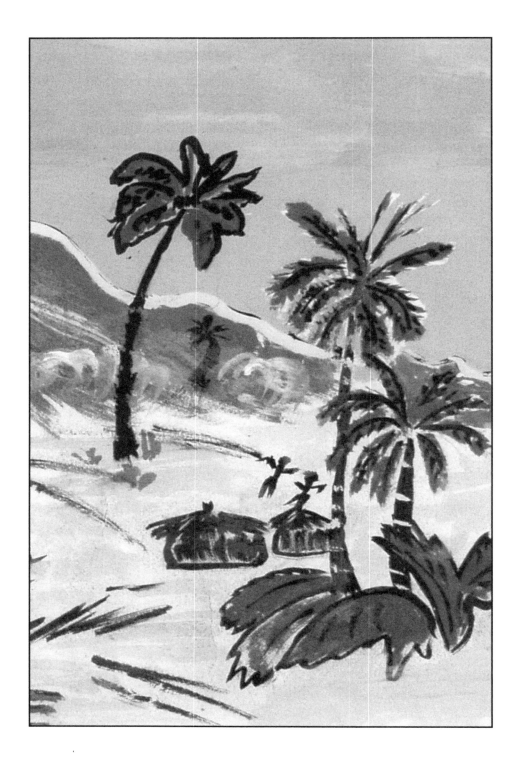

The Last Boy on the Planet

NEIL ARKSEY

'*Ashahadu an la ilaha ill Allah wa ashahadu anna Muhammadar Rasulullah.*
My name is Santoso. I come from Banda Aceh. This is the… nineteenth day
since I woke here on this beach. And I am *not* dead.'

The skinny boy recites this mantra many times a day. And at night,
waking with a start from troubled sleep, he repeats it.

Walking now on a bleached white beach, he keeps his eyes screwed tight
against the glare, against the painful beauty of the sun, sea, sand and
luminous green foliage that stretches as far as the eye can see in either
direction. It looks like Paradise. But it's not.

Waking on the first day and looking around, he thought perhaps he had died
and was being shown a glimpse of where he'd end up on judgment day. But
the place seemed so tranquil, so empty and still, and Paradise was meant to
be a garden bustling with dead souls. Where were they all? A short walk into
the trees had provided the answer.

The lush leafy canopy hid an ugly truth. A chaos of mud and debris.
And bodies. Too many to count. His awful memories had not been a dream.
He hadn't died after all. But plenty of others had.

His bare face, arms and legs are pocked with bites, the soles of his feet are
blistered from the burning sand. He shuffles, exhausted, from patch of
shade to patch of shade, always remaining on the fringe of the stricken
forest. He daren't go further in.

'Told you so.'

The sound causes his weary head to jerk. 'I told you so, Santoso.' A familiar rhythmn echoing through the branches above. 'Told you so.'

It is his father's words that he is hearing in the birdsong. His catchphrase, accompanied, more often than not, by a wagging finger, was used to scold or to gloat when he had proved a point. Stern-faced, his father frequently chided him for asking too many questions and for being too argumentative. Deep down though, Santoso feels sure his Papa was proud of him.

Was? *Was* or *is*? That's a question he can't face. It keeps popping up, but each time he pushes it away and tries to distract himself.

'Told you so. Told you so.'

The sound sucks Santoso back to an evening not so many months before, when he had sat by the boats with his father and the other fishermen, mending nets.

Santoso takes pride in being a fisherman's son and learning his father's skills. His grandfather and great-grandfather were both fishermen too. And Santoso has long been looking forward to the day he'll be old enough to join the men in their boats.

'Papa says most fishermen cannot swim. Is this true?'

The men chuckled. One of the elders nodded sagely. 'The sea has been good to us. The sea has always sustained us. If we trust in him, he will protect us too.'

'It's a tradition amongst us fishermen,' said another.

'We put our lives in his hands,' explained a third. 'And in return, he keeps us safe.'

Santoso had been about to ask another question but a nudge from his father silenced him.

When the men had finished mending the nets, they stowed them in the boats.

'You see,' said his father as they strolled home together, 'it is as I told you – not one of them can swim. I told you so.'

'You silenced me with your elbow. I was going to ask another question.'

'And I knew what was coming.'

'Really?'

His father nodded. 'I saw your shock at their answer. You wanted to ask why they all attend prayers yet talk about the sea as if it were a god.'

It was Santoso's turn to nod.

'Heh, heh,' chuckled his father. 'Told you so. Many fishermen wear amulets beneath their shirts. It would not surprise me if some also had little shrines or statues hidden away at home.'

'But the Prophet, peace be upon Him, forbade...'

'I know.' His father nodded. 'I know, Santoso. But if someone is superstitious, does that make them bad?'

Santoso shrugged.

'I don't think so,' said his father. 'These beliefs are so very old, yet they have real consequences for us men in the boats.' He gestured towards the ocean. 'When it gets stormy and rough out there, a fisherman who's a swimmer might be inclined to jump overboard and save himself. But a crew that can't swim has to stand together and ride out the bad weather and dangerous sea. There's a deep bond of trust forged around that old superstition.'

Santoso had been taught to swim by some boys from his school. Listening to his father, he had grown concerned that this might now exclude him from becoming a fishermen. But his father had laughed at his worries. 'Of course not. You are my son. That is all that counts. I may not be able to swim, but I don't believe in the sea god either. It is Allah the Merciful, the Lord of All Being, who watches over us and keeps us safe.'

Lifting a small handful of red berries to his lips, Santoso pauses and sniffs. Are these the kind he ate yesterday? Now that he's picked them, he's not certain. The bush looks the same but close up the berries appear smaller and a little lighter in colour. Could it just be they're not as ripe? He feels confident at least that they are not like the ones that made him sick when he first thought of eating berries to survive. Beyond that, he's way too weak and hungry to care.

Nineteen days ago, he worked out this wasn't Paradise. So where is he then? Somewhere up or down the coast from Banda Aceh and his home? Another country? How far did the giant wave carry him? He has a theory

but he still doesn't know for sure.

For the first few days, he was in too much agony to move far. Spasms and sharp stabbing pains ripped through his shoulders, back, arms and legs whenever he tried to move them. He must have wrenched all those muscles and tendons as he fought the wild ocean.

Even after the pain had subsided, he had remained in pretty much the same spot, believing that sooner or later someone would come along and find him. But nobody had.

During that time, he had concerned himself mostly with practical matters – finding water to slake his thirst, finding anything he could swallow that might dampen down the hunger, keeping out of the sun.

Even now, whenever possible, he keeps to the edge of the trees. The beach is swept clean by the sea and to begin with he had been able to pretend that the ocean's terrible assault hadn't happened.

That was before the smell. The sickly putrescent stench that still hugs the trees like an invisible fog. Despite some strong and persistent sea breezes, it has lingered all this time, growing stronger as the bodies decompose. He can still smell it – his nose hasn't got used to it.

To begin with, he had set off walking in the same direction that he is now heading in. But after a couple of days, he had lost heart, changed direction and ended up back where he started. Or so he'd believed at the time. Later he was not so sure. Much of the beach was featureless after all, and one fallen tree looked pretty much like another. It was hard to think straight, eaten alive by mosquitoes, sick with hunger and so permanently thirsty he even tried to suck moisture from rocks.

After a day's rest, he had set off once more. This time in the other direction. But again, two days later, he had given up and turned back. What distance had he walked? Not very far probably, because for the main part of each day, it was impossible to do anything but lie in the shade and stare out to sea, drifting in and out of sleep, trying to conserve strength.

He felt hopelessly weak. During the day, the most he could manage was a brief search for water or food in the debris beneath the trees. It was only at the cooler times – first thing in the morning and in the evening before it became too dark – that he really did much walking. And even then, it was

painfully slow.

After returning a second time to the place he'd set off from, he had sat propped up against his familiar tree, wondering what on earth he was doing. His struggle for survival felt futile. He hadn't spotted a single sign of human life on his travels. It was time he faced the awful truth – the cataclysm had killed everyone, every man, woman and child.

And now, several days on, here he is once again, a few berries in his stomach, shuffling along in the original direction. Before setting off this time, he marked the fallen tree so that if he turned back, he would know for sure he had found his starting place.

But this time he does not intend to turn round. This time he feels confident he is heading the right way – towards Banda Aceh and home. Walking in the other direction, the number of bodies he'd seen amongst the trees had gradually thinned out. In this direction, they are increasing.

And what will he find when finally he reaches the city? What if he finds no one? Not a soul. What if he really is the last boy on the planet?

<p style="text-align:center">* * *</p>

On that fateful morning, his mother and sisters had been with him and his father on the shore, preparing some food. It was busier than he had ever seen it, as most local families were outside too. The earlier ground-shaking had not been too severe – no one had been badly hurt. A couple of houses had collapsed and a couple more had lost some stilts and were leaning precariously, that was all. But there were likely to be aftershocks, Papa had explained. As a precaution, people were staying outdoors.

Life has to go on. Many of the fishermen had already put to sea for the day's catch and he was busy helping his father and uncle prepare their boat. Then the strangest thing happened. The bustle and chatter along the shore evaporated and an eerie silence fell upon the beach.

Everyone had stopped and looked up from what they were doing. They stared open-mouthed. The sea was draining away, retreating right down the beach. It dropped back way past where a normal low tide would take it. And way faster too – in a matter of minutes instead of hours.

There were gasps of shock and wonder along the shore. Amazement became amusement as people spotted one of the boats that had just put to sea – it had been comically dumped, along with numerous flapping fish, on the newly exposed rocky ocean bed. People laughed. They started whistling and clapping.

The next minute, squealing with delight, women and children were hurrying down the beach to snatch up the hapless fish.

A stranded fisherman had climbed out of the boat and was scratching his head. Papa asked Santoso to keep watch on their boat and nets, whilst he and his brother went to assist him.

Not long after, looking out towards the fishing boats that were still afloat on the sea, Santoso had noticed them suddenly jiggling wildly, as if they were little toys being tossed around by some unseen hand. Beneath them, a thin white line stretched through the azure sea.

As he stared, the white line seemed to thicken and throb. The next minute, before anyone had chance to react, a wall of white foaming water, as high as a house, exploded out of the sea and came crashing, roaring and hissing up the beach.

It was so incredible, so magnificent that for the tiniest moment Santoso's heart had leapt with joy not terror. Then he saw his mother and sisters knocked down like so many matchsticks, engulfed in an instant by the raging torrent. The giant wave came so fast, they and the others who were standing that far down the beach didn't even have time to look up and see their fate.

His father and uncle seemed frozen in their tracks. He yelled. They turned and began running. As did he. Beneath the deafening roar of the monster wave, he heard his father somewhere behind, calling to him. But he didn't dare slow or turn round. The sea came so fast, none of them stood a chance.

Tired from walking, Santoso slumps down in the shade to rest. Actually, he is way beyond tired, but at last he thinks he recognises some features of the landscape. Maybe. It's hard to tell because there is so much muddy mess everywhere, so much destruction. If his hunch is right, then he's close to home. But what will he find there?

That first wave had swept him up. It had carried him and the boat right

past their house and down the street towards the town. A couple of blocks on, he had managed to catch hold of the corner of a roof. He had hung on for all he was worth. After a while, the current had slowed right down.

Then it had changed direction. It started dragging everything back towards the sea.

He had seen people washed past, clinging to whatever floated. Bodies, cars, dogs, whole houses even – anything and everything was being washed away. But he had managed to scramble up onto the roof itself. And he had stayed up there till the waters subsided.

Heading back home through the muddy chaos and destruction had been like walking through a nightmare. Rivers ran down the streets, bodies and wreckage were strewn everywhere. On street corners, survivors stood weeping or clinging to one another for comfort.

The fishermen and their families lived in wooden huts on stilts. To his amazement, though many of the homes had been washed away, his own family's remained standing. Even more incredibly, his father was there. He was standing beneath the house, bedraggled-looking but quietly examining the structure for damage and trying to repair a broken stilt.

Papa.

How long had they spent together before the second wave came? It couldn't have been more than a few minutes. 'Your mother and sisters have been taken, Santoso. My brother too, I fear.' Papa's embrace had been stiff, his face stern. 'We must try to make the house safe.'

When the second wave came, it was dark and terrible. Considerably bigger and faster than the first, it had reared and rushed in with such speed that he and Papa barely had time to scramble up the steps before it struck.

Already weakened by the first onslaught, the stilts of the house gave way in an instant, collapsing beneath them with a terrifying crash. The world somersaulted about them. He, Papa and all their belongings, toppled head over heels, around and around each other.

The house span and the raging sea poured in through the windows. As the structure smashed against trees and buildings, it shuddered and shook. With each blow it was breaking apart till finally he and Papa, bruised and battered, were flung out into the furious swirling waters.

Papa had caught hold of a tree. And he, Santoso, had caught hold of Papa. The torrent was pulling more strongly than before and straightaway he'd felt his father's grip loosening. He had been terrified by the swiftness of that first wave. And he had been petrified by the violence of the second. But the thought of his father losing his hold and, unable to swim, disappearing under the current, had stabbed his heart with the most terrible panic of all.

Santoso had let go with one hand.

'What are you doing?' his father had barked. 'Hold on! Hold on for dear life!'

But he had let go altogether and begun to swim. The current took hold of him immediately, eager to carry him away.

His father had twisted round with a mournful cry, 'Santoso!'

'Don't worry,' Santoso had yelled back between increasingly frantic strokes. 'I can swim. I'll survive.' Then the angry torrent had sucked him under.

* * *

And where is he now? Did he fall asleep again whilst walking? He feels drowsy and fuzzy. There's a soft light around him, he's lying down and there's what looks like a silver cord running out from his arm.

'My name is Santoso,' he says. '*Ashahadu an la ilaha ill Allah wa ashahadu anna Muhammadar Rasulullah.* I come from Banda Aceh. This is the... twentieth day since I woke on this beach. Am I finally dead?'

'No,' says a gentle voice. 'Not dead. You're not on the beach anymore either.' A pretty woman in white appears at his side. 'You are safe now, Santoso. This is a hospital clinic. You're going to be fine.'

Did he faint? He remembers nothing after the beach. He is shocked to see vertical bodies. Bodies that move and speak. People, in fact. Living people.

'There's someone here to see you,' says the woman with the gentle voice. Reaching behind him with a surprisingly strong arm, she lifts him and positions him so he's sitting upright. 'That's better,' she says. 'Now, let me bring in your visitor.'

Papa looks smaller than Santoso remembered. Head slightly bowed, he approaches in silence, sits at the edge of the bed and stares. He seems frozen.

Santoso gazes back. He wants to warm him. Papa must have been frozen all this time with shock, with loss, with grief. What can you do to thaw all that?

'You survived,' says Papa.

Santoso nods weakly. Suddenly he knows what to say. He smiles. 'Told you so.'

The stony face twitches. Something glistens on the cheek. The arms reach out.

Santoso reaches too, reaches for his father and hugs. In return, he is hugged back so tight that the air is all but squeezed from his lungs. 'Papa!' He kisses his father's cheeks and to his surprise, the tears taste sweet.

'Let me look at you,' says Papa. 'My son,' he sighs. 'He has stayed alive all this time! How did you survive those murderous waves that killed so many?'

Santoso shrugs.

'Perhaps it was the sea god's protection,' says Papa. 'Or was it Allah looking after you?' He smiles. 'I suppose you think being able to swim saved your life?'

Santoso considers this for a moment. 'No, Papa,' he says. 'In the end, I was just lucky.'

Santoso's reunion with his father
The 'real' Santoso was found after 19 days of wandering on the beaches of Aceh's vast coastline. Ravaged by mosquito bites, malnourished and dehydrated, he was immediately taken to the Save the Children office in Banda Aceh to get medical help and to be registered as a missing person – thousands of parents who had lost their children were checking the Save the Children lists every day. An aid worker then took him to a hospital, where he was put on a drip. Whilst there, another patient recognised 'Santoso' and fetched his grandfather, who by huge coincidence had survived and was recovering at the same hospital. After Save the Children carried out rigorous identity checks, the grandfather went to look for the boy's father. Finally, Save the Children united a happy 'Santoso' with his father.

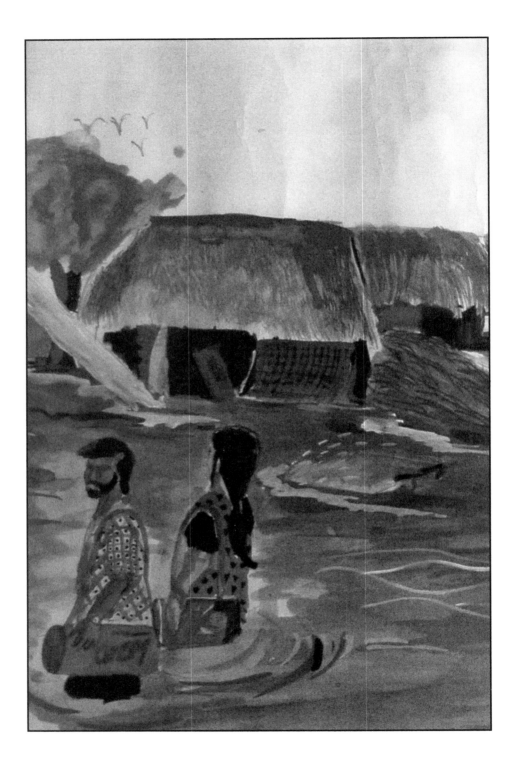

Zafar

BERNARD ASHLEY

It was just another Sunday morning. My father was still in bed – he works at the Blue Sea Hotel every night while we sleep. My mother had rolled up her sleeves to wash his blue shirts because he has to be smart. She rubbed them clean without a sound – he didn't like noise, my father, even with his bony head under the covers. I crept quietly out of the house – I had Sunday school that morning.

I met my best friend Khalid at the place where the dirt track from his house and the path from my house join up at the mosque right in the middle of our village. It was bustling with people that morning. Even though the ground was dusty and dry, the air was really muggy because of the monsoon rains the month before, and my forehead was already dripping with sweat.

Khalid and I have both been going to the Madarasa school to learn about Islam every Sunday since we were two years old. Now we are six. That day we looked smart as always in our white shirts and shorts, our schoolbags on our backs, and we smiled at the holiday people going to the beach carrying nothing but towels and cameras, and showing bits of their bodies that my mother would never show in public. But they didn't give us money that morning. They looked a bit tired – they'd celebrated their Christmas the night before, and made my father late coming home.

That same night, Khalid had waggled out a tooth in bed, and today he talked differently, with a lisp, and more slowly, as if he was older and more clever. He walked more slowly too, and looked at ordinary things as if he'd never seen them before. He looked at a common spider's web as if he were

an inspector, and nodded his head to confirm that it was well made.

That could be why we were late. When we got to the school, Sir was at the door with his strict face on. His other face, the one he wears before morning prayers, is kinder, smiling.

'You are late!' he said, fast and stern. As he spoke I noticed for the first time that Sir had always had a tooth missing in the same place that Khalid now had. 'Allah is not pleased with boys who sleep when study needs their open eyes.'

Naughty-boy Rafiq Sharif would have found an answer for Sir – he doesn't care about his crossness – but Khalid and I said sorry very quickly and ran into the schoolroom.

But I didn't get to say hello to the others, and Khalid didn't get to use his new voice. Suddenly, everyone stopped, eyes huge, mouths open wide. There was this big noise we'd never heard before, like ten jet planes landing. Out of nowhere a wide roll of water was racing up the street, breaking the fence and crashing into the yard of the school. We all screamed and pointed. As far as our eyes could see, water was drowning the ground, smashing into the posts and pillars of the buildings. It came as fast as a gale, and in seconds it was in through the school door and swirling strongly round our ankles and legs, knocking all the desks and chairs about.

It was the sea! The sea is blue, but in the yard it was muddy and grey, and inside the schoolroom it was as black as the depths.

'Upstairs!' Sir shouted. 'Everyone – upstairs! Walk! No running!' People were shouting and crying, holding on to one another and to the walls.

In the noise and panic, everyone was trying to save themselves, but we heard Sir's loud voice and we did what he said. Sir was in charge.

'Like the fire drill!' he commanded. But this time it was real.

We listened to Sir and instead of running in all directions we did what he had trained us to do. No running, no pushing – we obeyed the teacher because he was so strict. We left everything where it was, no looking for anything we wanted to save, and he marched us towards the stairs that led to where we knelt for morning prayers. From the outside we could hear people screaming, and the crashing of the water as it ran fiercely past the school and up towards the trees on the edge of town. But louder than

everything we heard Sir shouting, 'In twos, left, right. No pushing! No running!'

We did march upstairs in twos but then we scattered and raced to the balcony to see what was happening outside. Now the wide tide was flooding back, down to the edge of the sea from where it came – and in it floated tyres and trees and branches, sheets of corrugated iron and a van. And someone swimming who wasn't swimming, swirled and twisted by the water, a horrible sight.

Everyone was screaming and shouting. As the water went away, the road outside was steaming, the earth left stinking. We all wanted to run home now that the water was going back.

'You stay! You all stay! Till we see!' Sir was at the doorway at the top of the stairs. 'No one goes till I say!' he shouted.

There was never an argument with Sir. Except sometimes from Naughty-boy Rafiq Sharif. Naughty-boy always did whatever he wanted to do. But Rafiq Sharif wasn't there!

Someone shouted, 'Where's Rafiq?'

He wasn't anywhere to be seen. Everyone else seemed to be there, but not him. We looked at one another, then ran to the corners and behind the shrine to look for him. But there was no Rafiq. Prayer mats and holy books, lamps and oil and folded sheets, but no sign of Rafiq. We all thought we knew where he was. He must have disobeyed Sir and stayed downstairs, or run back down there when the water went away.

'Stay here!' Sir shouted in his sternest voice. 'You understand? All of you?' We nodded. We would do what Sir said.

'You do not follow me. No one follows me!' He pointed around the room at us all. And he went downstairs, to look for Naughty-boy. Rafiq could have been knocked off his feet by the black water and be lying injured among the desks.

'Another one!' Khalid suddenly shouted, his lisp loud, full of fear. And as Sir went down the stairs, our eyes suddenly shot back to the outside, and we stared from the balcony. Coming at us from the sea was a new great wave, as high as my house, wild water pounding with a roar like the end of the world, crashing all around the school. Nothing could stop it. We

screamed and shouted louder than ever, a mad panic, and kids jumped as the building shook, trying to get higher from the danger. And with the great wave, thrown about by it, were doors and umbrellas and trees and roofs and tables and rolling cars. And planks and planks and planks of bits of boats, charging on past as if the carts and cars in the road were nothing but small shells and stones on the beach. And there were bodies, hundreds of bodies, facing down, some in brightly coloured saris, some in holiday costumes, but no one swimming, no arms or legs moving, all were dead.

And there among the bodies, swirling out from the school door was Sir, who was not facing down but looking up at us. We shouted and cried to him to swim or hang on to something, but Sir was helpless. He stared up at us, and as we stared back and shouted to him, he seemed to wave to us. And the look on his face I shall never forget. It was his kind, patient, before-prayers look as he waved, and went under the water, and never came up.

We did not go downstairs. Everyone knew that they had to wait for the water to go back to the sea again.

Khalid said it, wisely. 'We wait. Water, however strong, cannot go uphill for ever.'

People looked at him. He seemed to be taking charge – was it just because he had waggled out a tooth the night before?

'There may be another wave. We must wait till we are fetched. And we must pray hard.' And he led us by turning to face Mecca, and kneeling.

We followed his example. We prayed. And yes, we cried. We all wanted to know if our parents, our little sisters and brothers, our friends were among those face-down bodies beneath and all around us, in amongst the wreckage of places and things.

After praying, hard and very fast, I ran to look out from the balcony. I looked for a blue shirt from the Blue Sea Hotel and for my mother's hijab. And everyone else was looking too, for terrible signs of dead friends and family. And as we watched in horror, this second terrible wave also began to go back to the ocean. And as it went, the sea that had invaded us brought down more trees and bushes from the higher ground, until the roads were left clogged, piled high, and steaming again. And the sight of dead bodies was not new anymore. There were too many to count, or to be astonished at.

*　　*　　*

At last, in the afternoon of a day that should never have been born – this was what Khalid called it – we were rescued by a van that came from the other side of the school, and in fives and sixes, we were taken to higher ground where there were shelters from the sun and blue plastic bowls of rice, and water to drink. Tents were being set up, a helicopter landed, and a lorry set off with people in white masks who looked like doctors in the hospital. But no one was standing and watching those things. We were running around the legs and trousers, the soggy saris and burqas, to find the ones we wanted. It stank of sweat and the ground squelched. We were calling and shouting and wailing and screaming and praying and cursing, and crying and crying and crying.

Everyone was searching through the camp in panic. Eyes stared without blinking from anxious faces. Names were thrown up into the air like stones.

But one of the names was mine. Zafar! A stone had landed! And there, suddenly, was my father – his blue shirt was flapping like a storm-ripped sail, but his strong arms reached out to me, his face alight with a great cry of 'Allah!' I shouted and ran to him, and I kissed his dear, bony head when he scooped me up and carried me in his arms like a baby. He took me to a cluster of people and there was my mother and my little sister. We hugged each other, and cried, and talked of others – how were they, where were they? Never mind our wrecked house and school, we were safe, we were alive.

And so was Naughty-boy Rafiq Sharif. He was with his family nearby – he had not been at school that day. Sir had gone looking for him only because we had not had time to call the register. Khalid ran to me. His family were all there too.

'Thanks to Allah you are safe,' I told him.

'And thanks to Sir,' said Khalid. 'We wanted to run home, but he told us not to, so we didn't. We obeyed him because he was so strict. If he had not been such a strict man, we would all have been taken away by the water.' I nodded. He was right.

'And we should not tell Rafiq why Sir went back,' Khalid said. 'It was not his fault, not being at school.' I nodded again. Khalid sounded wiser than ever. It would be good to be like him. And as I looked away from my friend and around the campsite, I secretly waggled at a tooth that seemed a bit loose.

It would be good to lose a tooth and gain Sir's and Khalid's wisdom.

Zafar's life in the emergency camp

Before the tsunami disaster, children of Zafar's age represented 25 percent of the Sri Lankan population. Afterwards, Handicap International found that only 10 percent of the population in the emergency camps were Zafar's age or below. The 'real' Zafar is still living in the same camp featured at the end of this story – his parents have no money to reconstruct their house. They fear the coming of another tsunami, so he is not attending another school. Because of this, 'Zafar' is finding it difficult to make new friends to replace the many he lost to the waves, and he feels sad. But he was delighted to hear from Handicap International that his story is included in this anthology! He cannot read English, but his father has promised to read the story to him!

ZAFAR

Yesterday's Dream

STEPHANIE BAUDET

Kama reached out towards the gleaming silver metal. He longed to run his fingers over the smooth curvature of the tank – it would be warm from the sun – and curl his fingers around the handlebars.

He didn't touch the motorbike. He knew better than that. If he was the owner, he wouldn't want some kid contaminating it with sweaty fingerprints. Instead he caressed it with his eyes, followed its red, white and blue contours, committing it to memory. Not that he needed to. He knew every inch of it from studying his plastic scale model. But this was the first time he had ever seen the real thing.

'Honda RC30,' he said to himself, as if he were alone. 'V4 engine. Four stroke. Six-speed gearbox. Built to win.'

Wimol tugged at his T-shirt. 'Come on, Kama. I thought you said you wanted to get back before your dad got home.'

'Or isn't my bike good enough for you now?' said Prakob, grinning.

Kama climbed onto the old scooter behind his two friends and they putted off along the road towards their village, Ban Nam Khem. They were late and if his dad knew he'd been hanging around in the town he wouldn't be pleased.

Kama knew his father meant well. When his friends had dropped him off, he stood on the beach, shading his eyes against the setting sun and watching as his father's fishing boat drew nearer. It had been a hot and humid day, but now a small breeze swayed the palm trees and blew through his T-shirt, chilling his sweaty body.

His dad's boat was new, and not only did it provide for his family but it was Kama's ticket to freedom. Freedom from his overcrowded house. Freedom from his nagging mum and pest of a little brother. Freedom from this village with its sprawling thatched houses and dusty roads.

Kama wanted to be a mechanic. He'd proved he was good with his hands, fixing scooter engines, and he'd kept his father's old boat going until he could afford a new one.

Now, with the new boat, his father had promised to save some of the profits from the fish to send him to college.

His father threw the rope ashore and Kama ran forward to secure the boat and help him offload his catch. The stench of fish mixed with exhaust fumes usually made him wrinkle up his nose, but today he was happy and he grinned at his father, patting the side of the boat.

'She'll bring you luck, this boat. She's a beauty.'

Kama's father straightened his back for a moment and laughed, showing white teeth and crinkling the corners of his weathered face. What a fine man he was, thought Kama with pride. Hard-working, wise, and strict, though always fair. He was well known in the village for his sense of justice, so much so that people often came to him for advice or to sort out disputes.

'She'll bring you luck too, son. She'll earn your college fees and once you're a mechanic, you can come back and maintain her for me!'

They walked home together through the village.

'What have you been doing today, Kama? Helping your mother, I hope. She has enough to do, especially with looking after Grandfather.'

Kama said nothing. All week he studied at school. Surely on Saturday he could spend some time with his friends?

'Next week, you'll have time off school to celebrate the New Year. See that you stay at home and help.'

There was no arguing with father and Kama's happy mood evaporated as they entered the house.

His mother swung round from her cooking and scowled at him. 'And where have you been all day? Come and help me.'

Kama caught his breath in the hot atmosphere, rich with the smell of spicy cooking. In the communal room, his aunt and cousin sat with his

grandfather, or Pou, as he called him.

Often Pou could cheer him up with tales of the days when he had first come to Ban Nam Khem as a tin miner. The village had sprung up around the mines and when the tin had run out, many miners had remained here and taken up other occupations, fishing or making jewellery for the tourists who had begun to flock to Thailand.

But this time Kama just wanted to be alone – not easy in this small house. His only response to the words of greeting was a token *wai* gesture, palms pressed together briefly, a slight bending of the head, but no eye contact. He strode through to the sleeping area. Soon he could leave here and follow his dream. He thought of the motorbike as he flung himself onto his bed.

One day he would own one of those, he thought. One day.

'One day what?' said a voice. Kama hadn't realised he'd spoken out loud. He raised his head and saw his little brother, Chet, sitting in a corner. He had something in his hands. Something red, white and blue.

Kama sprung up from his bed. 'What have you got there?' But he already knew what it was. He grabbed at Chet's wrists and tried to wrench the model bike out of his hands. 'I've told you not to touch that!'

Instead of letting go, Chet decided to be stubborn and he clung onto it. Kama felt anger and frustration surge up inside like a volcano about to erupt. He pushed Chet viciously and the boy fell backwards, letting go of the model to try to save himself, but not before it broke with a resounding snap.

With a wail, Chet crashed to the floor, hitting his head on the wall. That brought both mother and father in. While their mother comforted Chet, Dad silently looked at Kama, who turned his eyes away, not out of shame but in an effort to control his anger so that he didn't say anything else to make things worse.

With no dinner, he sat gloomily on his bed, flicking through an old bike magazine and from time to time fingering the broken model. Later when the others came in, he pretended to be asleep.

The next morning, Kama's anger had gone and although he considered apologising to his mum he decided that he wouldn't – after all, it had been Chet's fault not his.

Instead, to make amends, he picked up the water containers.

'Come on, Chet. Let's fetch the water,' he said, thrusting one of the buckets into his brother's hand.

They left their aunt and cousin eating breakfast with their mum and Pou and went out into the bright sunshine. It was already very hot and the air was heavy with humidity. Kama looked at his watch. Nine-twenty. Their father had already left to prepare the boat for another day's fishing.

The two boys headed for the village well. Neither had bothered with shoes and the dusty track was hot against their hardened soles. There was no wind and very little sound except for the birds. They were certainly making a racket this morning.

Mrs Choprasi's goat was acting strangely too, tugging at its tether in a frenzy. As the boys passed, it finally broke free and ran back through the village towards the trees behind. For an instant, Kama thought of going after it, but then a flash of sunshine caught his attention and he turned his head to see what it was.

The bike stood there. The same one as yesterday. The Honda RC30. Whose bike was it? Who in this village could afford such a bike? It must belong to a visitor or maybe a tourist.

'Just a minute, Chet,' he said, wandering off towards the bike.

'It's the same as your model,' said Chet, feeling no guilt about what had happened the previous evening.

As they reached the bike, there was a sudden and uncanny silence. As if a sign had been given, the birds abruptly ceased their cries and flew off in one large flock. At the same moment, a cry went up from near the beach, followed by others, rising to a hysterical pitch. All were shouting the same thing.

'Run! It's a tidal wave!'

People were running towards them and Kama could see their father in the crowd.

'Jump on my back!' he said to Chet and he hoisted the little boy into a piggy-back and began to run towards the trees behind the village.

A six-year-old boy is no light weight and Kama found it difficult to move quickly. The trees still seemed so far away and his steps were slowing.

He could hear it now above the screams of the people. A roar. Growing in volume, crashing and thundering like some enormous runaway train. Kama did not look around. That would waste precious time. He wanted to, though. He had a desperate urge to put a face to the monster, to see what they were up against. He'd heard of tidal waves before but never seen one.

They reached the trees. Palms were no good – he needed a tree with branches. He could hardly get his breath, his lungs felt raw. The noise in his ears grew but he heard Chet's whimper as he thrust him up the trunk of a tree.

'Grab the branch!' he yelled. 'Hold on!'

There was no time for Kama to climb the tree. He turned just as the water hit him, scooping him off his feet like some scrap of flotsam.

He thought he heard Chet scream as he was carried away in the boiling sea amongst uprooted trees and sections of thatched roofs from the houses. At times, he was dragged underwater for so long that he became light-headed and almost gave in to the overwhelming urge to open his mouth and breathe. Then some spark of will gave him the strength to last just that little bit longer.

At last he felt the current diminishing but a thought had occurred to him. He had to find something to hold onto before the water drew back again, for surely that surge would be just as strong. If he did not secure himself, he would be swept out to sea.

The water began to retreat. Kama tried to stand up and found that he could. In those few seconds, he managed to scramble onto higher ground and even when he was well away from the water, he kept going despite absolute exhaustion. His head felt light and the landscape around him lurched and tilted. His legs didn't seem to belong to him, even the long bleeding gash on his thigh didn't hurt at all.

At some time, he must have collapsed onto the ground. When he awoke, his vision had cleared. He looked at his watch but it had stopped, so he just lay there, staring at the blue sky.

The sun had dried him and it was the heat that finally made him sit up and look around. A small lizard scuttled away and he realised that he was far above the water line.

Shading his eyes, he looked towards the sea and the village, but he was too far away to see anything.

Slowly, Kama got to his feet. His legs felt weak but he could feel them again – and the cut was throbbing.

* * *

There is nothing left of the village.

Kama stares at the expanse of mud, at the few remaining bits of houses left standing. This can't be true. This is a nightmare and he'll wake up in a minute and share it with his family. They'll shiver and say it was only a dream. *Come on, Kama, get up and go and fetch the water. We want our breakfast,* they'll say. *Do your job.*

Kama stands with his toes sinking into the mud. The air seems full of dust and he wipes his watering eyes. He is aware of sounds now. Human sounds. A woman sobbing. A child wailing. There is debris everywhere – and bodies.

A small hand tucks into his own and he looks down to see Chet.

'Dad is here,' he says. 'And Pou. We are to go to the school. It didn't get crushed. People are coming to help us.'

This time it is Chet who leads Kama.

They trudge across the muddy expanse. Here is where the well was. Now a broken fishing boat lies stranded on top.

Kama feels something hard and smooth under his foot and bends down to see what it is. He scrapes away the mud to reveal a smooth curved metal object. On it is a golden wing and underneath the word HONDA. It is the bike's fuel tank.

'Come on,' urges Chet.

Grandfather and father and two sons hug each other. Kama does not want to think about where the rest of his family is.

Only Grandfather speaks. His voice has aged. 'We must be strong,' he says. 'We have survived. We must stick together and help each other.'

Kama looks at his father's face. His eyes are blank and unfocused, and dry, though there are streaks of dust marking the path of his tears.

The strong decisive man is gone. His shoulders hunch and the muscles of his neck are taut as if he is still bracing himself against the waves.

Kama is shocked and frightened by his father's face and for the first time he faces the enormity of the truth. His mother is dead – and his aunt and cousin. Swept away when their house was hit.

Now it is as if his father's soul has been swept away with them, leaving the empty shell of his body. This once strong man, to whom villagers came for advice, is now nothing. He has lost his wife, his house and his means of income, the boat, and now he sits hunched and his hands tremble.

There were two waves, Pou says, the second even higher and more vicious than the first. It is a miracle that anyone survived. It is given a new name now. Tsunami.

Kama remembers last night and the anger he had felt towards his mother. Now he will never be able to apologise.

He thought of the motorbike, broken and buried in the mud. Just a lump of metal. An inanimate thing that he had loved and thought about more than his own mother.

His dream. *His* future. When had he ever thought about anyone besides himself?

Their father is still silent. Kama sees the future clearly now and surprisingly feels his despair lift a little. He will make his mother proud of him.

'We'll be OK,' he says, grasping Chet's hand. 'I'll look after you now.'

His father turns his head slowly and looks at him for the first time. He seems to nod slightly and a small sound issues from his lips.

This is a start, thinks Kama.

Yesterday's dream has gone and tomorrow is just beginning.

Helping bereaved children
Children who had lost parents, like the 'real' Kama and Chet, were particularly vulnerable and UNICEF acted rapidly by sending teams of counsellors. To prevent bereaved children from going astray, counsellors and teachers knocked on doors in wrecked villages and emergency shelters to find them and to help them back to the protection of school. By February, UNICEF had helped to ensure that, for most children, their future wasn't 'yesterday's dream'.

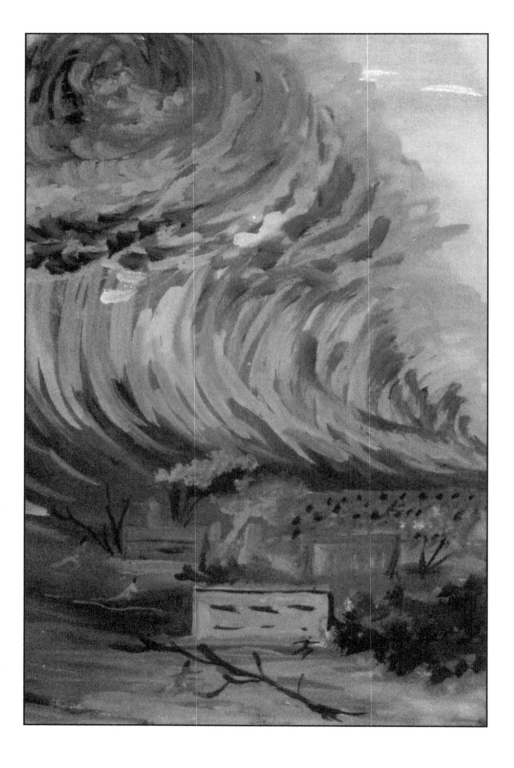

Maya's Story

TIM BOWLER

Dawn.

Grey light over a grey sea. A low, angry swell. The island hasn't slept. No one has slept since the waves rushed in. No one except the dead; and they're not at rest. I hear them whispering in the surf.

The shoreline stretches before me. It's like a vast, open wound. No houses left at all, no sign of life. I wander down to the spot where our home once stood. Nothing there now but branches, tree-trunks and ripped-up earth. On the site of Grandfather's house, just flotsam and the shattered hull of a fishing boat coughed up by the tsunami.

Where Grandfather is now, no one knows.

More light in the sky: a straggle of blue, the first glimmer of sun. I'm shivering. I try to think, try to forget. I can't do either. I just stare. But even this is hard. All is devastation. Trees lie like carcasses around me. The few still standing move limply in the breeze wafting in from the south. Once it would have carried with it the scent of wild orchids. Now it brings the odour of decaying bodies.

I hear voices somewhere to the right: a woman crying, another hushing a baby. Further away, men calling to each other. Someone's found another corpse. Then, much closer, Father's voice.

'Maya.'

I don't answer. I'm not ready to speak. He tries again.

'Are you all right, sweetheart?'

I turn and look at him. He's standing a few feet away and the burgeoning

light is falling on his face. The change in it is scary. Just a few hours ago he seemed young, almost boyish. Now he's as grey as the dawn. He stares at me through blotchy eyes, then bends down and starts picking through the branches on the ground. I find my voice at last.

'What are you looking for, Father?'

'Hari's football.'

'You won't find it there.'

'Maybe not. But I've got to try. I just feel it might help him.' He goes on rummaging about for a few minutes, then grunts and straightens up, empty handed. 'I guess you're right. It's probably halfway to India by now.'

I walk over to him.

'Come on, Father. We've got things to do.'

He looks hard at me.

'Are you sure you still want to go through with this?'

'Yes.'

'The elders won't agree to it, you know.'

'We haven't asked them yet.'

'I know, but they won't. I'm just warning you. They might even tell you off for wasting their time.'

'I've made up my mind.'

He frowns.

'And I know what that means. You've got a will of iron, Maya, you really have. But don't expect the elders to give in to you just because I always do.'

'You don't always give in to me. But they will. I'm going to keep on at them until they agree.'

He watches me in silence for a while.

'Well, there's no harm in trying,' he says at last. 'You're a determined girl and a brilliant student. Both those things will help your case. But listen, Maya: this is a crisis, the biggest in our history. Everything's in chaos. The Islands took the full force of the tsunami, and the Nicobari tribe has suffered the most. Up at Port Blair, they're saying that we've lost thousands. Our family has been one of the lucky ones.'

I think of Grandfather but say nothing. Something in Father's face tells me this is not a subject I can mention yet.

'So remember,' he goes on, 'the elders have got lots of things to sort out. They might not even hear you. They might just dismiss you.'

'What for?'

'For being too young.'

'I'm not too young. I'm eleven.'

He shakes his head.

'I love your confidence but you must try to see it their way. An eleven-year-old girl is hardly someone they'd normally consider for something so important.'

'But I can do this. I know I can.'

'So do I.'

'Well then.'

He gives my hand a squeeze.

'It's not me you have to convince. That's all I'm saying.' He runs his eye over the ground again. 'Come on. We're not going to find Hari's football here. Let's get going.'

We set off towards the interior, picking our way over the fallen trees. I can hardly bear to look about me. This used to be a place of peace and beauty. But that place is gone. I'm walking over the graves of houses and the ghosts of those who lived here.

All of them I knew.

I see Father speeding up and I do the same. It feels slightly disrespectful to be hurrying like this but it's painful to linger here. What once was rich and vibrant is now a cemetery, a landscape ravaged by an enemy no one suspected. I hear weeping somewhere to the left but I don't stop. I can't stop. I'm worrying too much about Father.

And worrying even more about Hari.

He's waiting for us with Mother by the ruined schoolhouse. He looks tiny as he stands there, his hand loosely in hers. He's always been small, even for a five-year-old, but the loss of his friends has hit him hard and he's now hunched over as though he wants to disappear into the ground.

He hasn't spoken a word since the tsunami.

I look over the shattered schoolhouse. Another place I can hardly bear to see. I used to love coming here. It was like a second home to me. But now,

with its roof gone and the upper sections of the walls smashed in, it's like a kind of skull.

Father bends down to Hari.

'We didn't find the football,' he says. 'But we'll get you another one, I promise. An even better one.'

Hari glances away without a word. I bend down too and look at him. His eyes brush over mine. He doesn't want to look at me but I hold his gaze somehow.

'It's going to be all right, Hari,' I say.

His eyes are misty with pain and he quickly looks away. I kiss him on the cheek and straighten up to see Mother watching me.

'Are you ready?' she says.

'Yes. And don't try to talk me out of it like Father did.'

'I'm not going to.' She glances at Father, then back at me. 'And I'm sure your father was only trying to spare you disappointment. It's very unlikely the elders will agree.'

I say nothing. I'm watching Hari. He's wandered towards the ruined school. I walk over and take his hand. There's no grip but he doesn't pull away.

'Hari? Did you want to go inside?'

No answer. No change of expression on his face.

'Come on, Hari. Let's look inside our old school.'

It's a mistake, not for Hari but for me. I should have known better. My old classroom is a desolate place. Once it had shelves lined with books, and posters on the walls, and mobiles hanging from the ceiling. There are no books now, or posters, or mobiles. There are barely any walls and the room is open to the sky. The sun, now high and bright, is beating down on me; and my fears are coming back.

I've tried to keep them locked away, for Father's sake, for Hari's sake. I've tried to be strong. But I don't feel strong. I push the fears away. They come swirling back, demanding my attention. I push them away again.

I walk with Hari to where the blackboard was. Nothing there now, not even the wall, and I can see all the way down to the shore. The sun goes on beating down, bright on my face, bright on the sea; and the sounds and

pictures slip into my mind again, and grow, grow, grow.

Go back, I tell them. *Go back into the darkness.*

They don't go back. They stay, they move, they multiply.

* * *

I see faces whirling in a vortex. Boxing Day morning: flamingos, pigeons, seabirds diving for fish; lizards skittering over the ground. Father and Mother talking, Hari bouncing the football they gave him for Christmas. The pages of a book: *Pride and Prejudice*. Sun falling over the words, over my hands, over me as I read.

A tremor in the ground. Another. Father gabbling something, panic in his voice. Shouts over the island, people rushing. Father grabbing my hand, Mother grabbing Hari's. Then racing, tearing, stumbling inland. More tremors, more shouts. The sea drawing back like a bowstring ready to fire.

Then chaos. A confusion of images, feelings, terrors. Shrieks everywhere, madness everywhere. I've lost Father's hand but I can hear him yelling nearby, and Mother is just behind; they're both shouting at me to run for the high ground. And I'm running and running and running, but I'm worrying about Hari. I haven't heard his voice. All I can hear is the deep, malevolent roar of surging water.

Screams now, far behind me, screams cut off and swallowed by the roar. I don't look back. Father is screaming too, screaming at me to run. So I run and run and run. At last the higher ground, crowded with people jostling, fighting, scrabbling for space. Father and Mother catch me up, Father carrying Hari, and then we look back.

And there is the wave feeding upon the island, gobbling land, houses, people, everything in a mouth of boiling foam. A frenzy of greed, then the slow heave of its body as it pulls its prey back into the ocean.

But still the sea is hungry. And what the first wave spares, the second does not. A black wave this time, louder, heavier, more terrifying still. Nothing can stand in the way of this one, and nothing does. It plunges over the island, deeper, higher, further than the first, all the way to the base of our hill and up the slope, rising towards us, higher, higher, a tongue reaching

out to lick us from the summit.

But we are to be spared.

And slowly, reluctantly, the tongue draws back into the sea.

<p style="text-align:center">* * *</p>

The pictures in my head draw back too; and I breathe again in the haunted classroom. I look out over the sea. It's glittering like an emerald. And I remember what I have to do.

'Come on, Hari. We must go.'

Father and Mother are waiting outside. They look anxiously over at us and I can tell they see the pain in my face. Father opens his mouth to speak. I hurriedly cut him off. He mustn't start worrying about me. Hari is the one who needs help.

'Father, where did you say they're all meeting?'

He looks quizzically at me. He knows I know the answer to this.

'At the festival ground in Port Blair. They've converted it into a school. But Maya, are you...'

'I'm fine. I'm OK.' I look quickly down. 'Come on, Hari. Let's go and meet your new friends.'

And without looking back at Mother and Father, I lead Hari off down the path.

There's no more talk between us as we make our way towards Port Blair, and I'm glad of that. I need to think, need to prepare myself. I know Father is right. The elders will probably dismiss me for being too young. But I have to try. I can't just stand back and watch my island die.

The sun climbs higher. Warmth is returning and somehow, even amid the devastation, I feel a glimmer of strength inside me. I look down at Hari. His hand is still locked in mine and he is still locked in himself. His eyes stare down at the ground. I glance over my shoulder at Mother and Father. They too are holding hands. They too are staring down.

But the path is now coming to an end and Port Blair is ahead.

The festival ground is a depressing place. It's hard to imagine that only a few hours ago we were preparing to celebrate the multi-faith festival of the

Andaman and Nicobar Islands here. Now there's an atmosphere of panic mixed with listlessness: adults bustling about, busy with this, busy with that, talking, arguing, gesticulating, and at the same time, groups of children sitting around, not talking or moving or playing, just staring.

One little group catches my eye. They're about Hari's age: little boys, little girls – tiny, frightened kids, just like him. One boy's even holding a football. I could be looking at my own brother. Certainly Hari's looking at him.

None of the faces are familiar.

'They're the tribal kids who've escaped from Car Nicobar Island,' says Father, who's watching them too. 'Poor little mites. People are saying their whole island's been wiped out.'

I look at him, then back at the children.

'Then I'll start here,' I say. 'Come on, Hari. Come with me.'

'Maya,' says Father. 'You need to speak to the elders first.'

'No, I've changed my mind.' I'm still looking at the children. 'You speak to the elders first.'

'But…'

'Please, Father. I know this is the best way.'

'But it's you they'll need to speak to. You're the one who's got to convince them, not me. They'll only turn me down.'

'I know they will.'

'Then why…'

'Father.' I look round at him. 'I know what I'm doing. Please speak to them. Find Chachaji if you can. He'll listen to you.'

'He'll still say no. And his word carries more weight than anybody else's.'

'When he says no, bring him to me.'

'But what are you going to do?'

I look back at the children.

'I'm going to start.'

And without another word, I lead Hari towards the children.

There's something about this group that sets them apart. Something detached. Their eyes seem to stare inwards, not outwards. Some glance absently up at me as I approach but there's no expression in their faces, no interest. Why should there be? These children have lost everything. Why

should they care about me? They all look away again, except for the boy with the football.

He continues to watch.

I stop before them. No one takes any notice of me, apart from the boy with the football. He's clutching it to his chest, like a woman clutching a baby. His face is like a mouth that cannot scream. The others go on staring at nothing, but one or two are starting to look up again, starting to be aware of me.

I glance round to where Mother and Father were and see that they've gone. A curious pressure in my hand makes me look down. For the first time I can feel Hari squeezing it. I bend down and whisper to him.

'Hari, go and sit with the boy with the football. I want you to look after him.'

To my surprise, Hari goes and sits down next to the boy. The boy twists his dishevelled face round and looks Hari over, then turns back to me. The others are watching me too now, all eyes fixed upon me. I straighten up and look back.

Eight boys and seven girls. Fifteen frightened kids.

Just like me. Another frightened kid. Frightened of what I've come to do, frightened of failure, frightened of myself almost; and frightened most of all of these little tots. It's almost as though the wave has come back. I can hear the roar again surging over me, over my island, over my people. I can see the black shadow swallowing up my life. But the shadow in these faces before me is greater than mine, far greater, so great that I'm ashamed of my fears.

'My name is Maya,' I begin.

There is no answer. They are as silent and withdrawn as Hari.

'I'll be your teacher. I'll be your friend. I'll teach you English and arithmetic and poetry. I'll tell you stories. Do you want me to do that?'

Still they do not answer. Their eyes watch me with the same glazed expression. Only Hari is not watching me. He is staring at the boy's football. I hear voices behind me and turn.

Mother and Father have found old Chachaji and the three of them are approaching. They stop a few feet away and Chachaji beckons to me. I look back at the children sitting on the ground.

'I'm going to speak to Chachaji,' I whisper to them. 'That's the old man with the beard. He's the leader of the elders. I'm going to tell him I'm your new teacher. Then I'll come back and we'll start our lessons.'

Again no response. No word, no change of expression. I take a deep breath and step over to join the others. Chachaji fixes his eyes on me. I've looked into them many times. Wise and stern yet not without kindness. But it's hard to read them today.

'Maya,' he says. 'What's this I hear from your father?'

'I'm going to teach the children from Car Nicobar Island.'

He shakes his head.

'You're a good girl. We all know that. And you're a bright girl. The best student on the island. We're all very proud of you. But this...' He glances towards the children sitting just a short distance from us. 'This isn't for you. It's a noble thing you're offering to do. But this is a job for a professional teacher. Not an eleven-year-old girl.'

I force myself to look into those unwavering eyes.

'And how many teachers are left, Chachaji?'

He looks back at me. And for a moment he is silent.

'Tell me, Chachaji. How many teachers are left?'

I see a shadow pass over his face, the same shadow I have seen in the faces of the children; and for a moment he becomes a child himself to me, as broken and displaced as they are. Then, almost at once, he becomes an old man again.

'There are no teachers left, Maya,' he says.

He is holding back the tears but only just. And I am doing the same, only just. I reach out and touch him on the arm, then turn back to the children. They're watching us all with the same blank expression.

I walk over to them, my heart pounding. I feel Mother's and Father's eyes upon me, and Chachaji's eyes upon me. And most of all I feel the eyes of the children looking up. But the boy with the football isn't watching me.

He's talking to Hari in a low voice; and Hari is talking back. I cannot hear what they're saying, and I don't want to. Hari reaches out and touches the football. The boy gives it to him, then looks up at me. I smile at him. He looks back with his small, scared eyes.

'What's your name?' I say.

'Karuppu.'

I look at one of the girls.

'What's your name?'

'Farida.'

I go round the group. I'm terrified they won't speak. But they do.

'Sakila.'

'Elango.'

'Lavanya.'

'Ravi.'

One by one, they give me their names. I look at Hari. He's holding Karuppu's football. His eyes are still frightened. All eyes are still frightened. I try again.

'I'll be your teacher. I'll be your friend. I'll teach you English and arithmetic and poetry. I'll tell you stories. Do you want me to do that?'

Silence. A long silence. In the distance the sun sparkles upon the sea – a deep, calm sea, strangely benign. Hari stirs.

'Yes,' he says.

I look at him. He's clasping the football tightly but he's watching me. So is Karuppu. So are all the others.

'Yes,' he says again.

'Yes,' says Karuppu.

I look round at the others and see heads nod. A murmur goes round the group, a murmur of assent. I feel a hand on my arm and look round to see Chachaji standing there. He's leaning close and he has tears on his cheeks.

'Forgive me,' he whispers.

I see Mother and Father watching me. They look grave but I can feel their pride. Chachaji rejoins them and they look on for a few moments, then turn and move off.

I look back at the children. The shadow still hangs over them, just as it hangs over me. But it's moving now, slowly, slowly, slowly. Perhaps – some time in the future – it will be gone. I smile at them, as deep a smile as I can manage. One day they will smile back. I will work for that. I will wait for that.

One day they will smile back.

Activity centres in the Andaman and Nicobar Islands
In the months after the disaster, Save the Children set up activity centres
in the Andaman and Nicobar Islands to educate, entertain and protect
those same vulnerable young children that the real 'Maya' wanted to help.
Initially set up to make sure that the children's education didn't suffer, the
centres now run sports activities such as badminton, volleyball and cricket,
as well as drawing, reading and dancing. The children are central to
planning and running these centres – they choose sports equipment and
decide which toys to buy. Boys and girls of all ages are equally represented.
A five-year-old boy pointed out in a recent meeting, 'Little children need
different toys from older boys.' 'Maya' would be proud!

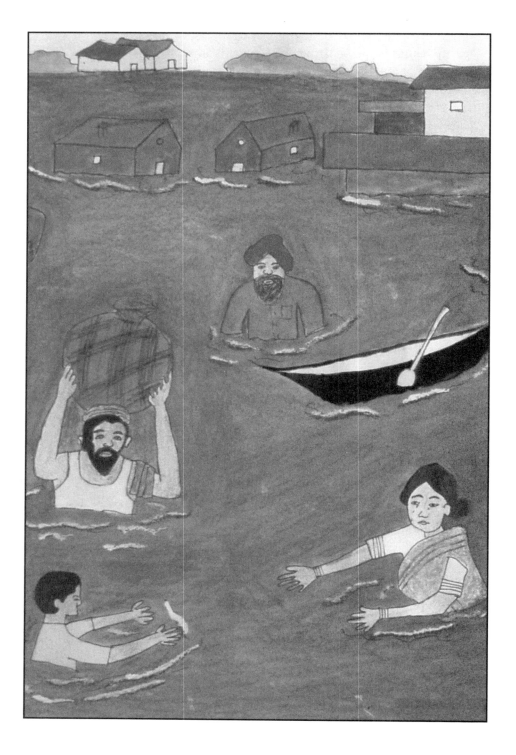

The Spirit of Uncle Vijay

JOHN FARDELL

'Help me with this basket,' called Sanjeev's mother. Her plastic basket was too small for the vegetables and rice, and one handle was broken. Her husband had brought back a good catch of fish earlier in the morning, and she'd been able to trade some for this other food. They'd eat well for a few days – if she could get the food home. Their hut was further up the beach, in the middle of the sprawling shanty town of flimsy makeshift buildings. 'Sanjeev,' she called again, 'come and help.'

But her six-year-old son, Sanjeev, pretended not to hear, and ran ahead with his two younger brothers and the family dog, Vijay. Sanjeev had just found an old tennis ball, near where some bigger boys were playing cricket. The ball was split open, and no good to them anymore, so they'd said he could have it. It wobbled when you threw it and it didn't bounce or roll, but Sanjeev didn't care, and he knew Vijay wouldn't either. They had a ball, and they had days and days left to play with it before school started again.

'Catch, Vijay!' shouted Sanjeev, throwing the ball in front of the dog. But Vijay ignored the ball and let it land in the sand in front of him. The scruffy yellow dog was looking out to sea, his pointed ears pricked up, his black nose twitching. He whined, and fidgeted on his paws.

'What's wrong, Vijay?' said Sanjeev. Maybe the dog was looking for dad's fishing boat. 'Dad came back earlier, remember,' Sanjeev told him, pointing to the small wooden boat, tied up near some others. 'He's gone into town.'

But the dog would not be placated. Continuing to whine, he scampered between Sanjeev, his mother and his brothers, as if he was trying to round

them all up. Vijay never behaved like this unless a thunderstorm was brewing, but today the sky was clear and blue, the air pleasantly warm with a light breeze.

Vijay was normally the most easy going of dogs. He'd started life with no name, one of the many stray dogs that roamed the shanty town. Sanjeev's Uncle Vijay had found him as a puppy, wandering all alone up by the busy main road, and had persuaded Sanjeev's mother to take him into their small family hut as a pet. She'd called the puppy Moti, and he and Sanjeev, then three, had quickly become inseparable playmates. Then, a few weeks later, Uncle Vijay had been killed in a bus accident and Sanjeev's parents had decided to rename the puppy after him. No one could replace funny, open-hearted Uncle Vijay, but it had seemed fitting to commemorate him in something living, something he himself had rescued with such typical kindness.

Three years on, Sanjeev could hardly remember his uncle. But he felt as if he could when people smiled and said how much the gentle, happy-go-lucky dog reminded them of Uncle Vijay.

Sanjeev's mother stopped to adjust her grip on the basket. Vijay scurried round behind her and made little darting jumps on the sand, trying to drive her onward up the beach. She looked at the sea. What was frightening the dog? There was nothing. The sea was calm and blue and... No! Something odd was happening. The sea was disappearing, rushing back towards the horizon in waves, at astonishing speed. Other people were noticing, shouting and pointing as more and more sand was exposed. Sanjeev and his brothers turned and watched in amazement. The sea was drawing back way past the low tidemark, exposing a huge stretch of the normally unseen seabed. Sanjeev could see the silver bodies of stranded fish gleaming in the sunlight. Some people were rushing to gather up this unexpected harvest of free food. Sanjeev started to run after them, eager to explore this strange new playground.

But Vijay headed Sanjeev off, blocking his way, barking now. Vijay never barked. The dog's anxiety added to the mother's own uneasiness. 'Stay with me,' she ordered her boys, with unusual sternness, and even Sanjeev obeyed. Then she heard shouting behind her. Way up near the main road, people

were standing on the flat roofs of the bigger concrete buildings that were up there, yelling and pointing out to the now-distant sea. She couldn't hear what they were shouting. She turned back to the sea. What were they pointing at? Now she saw it: a line of foaming white, filling the entire horizon. It was getting bigger. Nearer. She dropped the basket and, as vegetables and rice went everywhere, she tried to grab her three children. She could carry only two, but Sanjeev could run faster than she could. 'RUN, SANJEEV!' she shouted, scooping up her two youngest sons in her arms. 'RUN!'

Sanjeev ran, tennis ball forgotten. Everyone was turning and running now, surging through the chaotic maze of huts towards the main road. Sanjeev quickly overtook his mother. He turned to check she was behind him, but was swept up by the fleeing crowd. Where was mum? Where was everyone running to? Then he saw their family hut. Home. He veered away from the crowd and ran along the familiar muddy lane. He'd be safe at home. Mum would catch up with him there.

His mother ran up through the shanty town and across the main road, a bewildered wailing boy in each arm, Vijay at her heels. But where was Sanjeev? She scanned the crowd ahead. Couldn't see him. But he must be ahead. He had to be. She reached one of the concrete housing compounds, still clutching her two youngest boys as the crowd swept her up the stairs to the flat roof. 'SANJEEV!' she yelled. She could not see him. Sanjeev had almost reached their hut when Vijay caught up with him, a cannonball of yellow fur, barking and bounding at him, physically forcing him away from the hut, and up the beach.

From the roof of the concrete building, Sanjeev's mother watched the three-metre-high wall of foaming water slam in from the sea with unbelievable speed and unstoppable power, instantly obliterating everything on the beach, blasting the shanty town into matchwood. She instinctively crouched, shielding the two boys as the massive wave crashed into the concrete building. A deafening impact. A towering plume of white spray, smashing down on them. Screaming. Screaming everywhere.

The mother, sprawled out flat and soaked to the skin, still had each boy gripped by the arm. The boys were terrified, drenched and crying. Still alive.

The building had been high enough. Just. But Sanjeev? She staggered to her feet. Everywhere below was a rushing, swirling torrent of chaos and destruction. The terrible wave had rushed inland for another kilometre. Now it was pulling back, sweeping boats, cars, building wreckage and uprooted trees back out to sea. And people. Everywhere people. People screaming, people clinging onto railings, people swimming for their lives against the undertow. And people who were not screaming or clinging or swimming, and who never would again.

'SANJEEV!' she screamed. She turned to the other people on the roof, many of whom she knew. 'Has anyone seen my son Sanjeev?' she implored, shouting above the water's roar.

'I thought I saw him running to your hut,' said a neighbour. 'I shouted to him, but he couldn't hear me. I'm sorry.'

The mother's insides went cold. She hadn't told Sanjeev where to run to. And he had run home. As the wave retreated down the beach, the full extent of the devastation was exposed. Their entire sprawling neighbourhood of makeshift huts, which just minutes ago had been alive with noises and smells and colour and friendships and arguments and plans and ambitions and history, was now a totally flattened heap of sodden wreckage. Sanjeev would not have stood a chance.

'MUM!'

Sanjeev's mother spun round. And she saw him. Sanjeev was standing on the roof of the neighbouring concrete building, as drenched as she was, waving his arms at her. Beside him, keeping him back from the edge of the roof, was Vijay.

As soon as the wave had receded far enough, most people evacuated the roofs of the concrete buildings, some to search for lost family members, others to retreat further inland. No one knew whether there would be more waves but it didn't feel safe near the sea anymore. Sanjeev ran to his mother. She clung to him, crying with joy and relief as he told her how Vijay had stopped him going to the hut and had made him run up to the concrete buildings. 'We got onto the roof only just in time!' he gabbled, reliving the terrifying moment, nearly crying himself now.

'Vijay saved you!' she cried, letting go of him briefly to hug the wet dog.

This powerful painting is by a 15-year-old boy from the Andaman and Nicobar Islands.

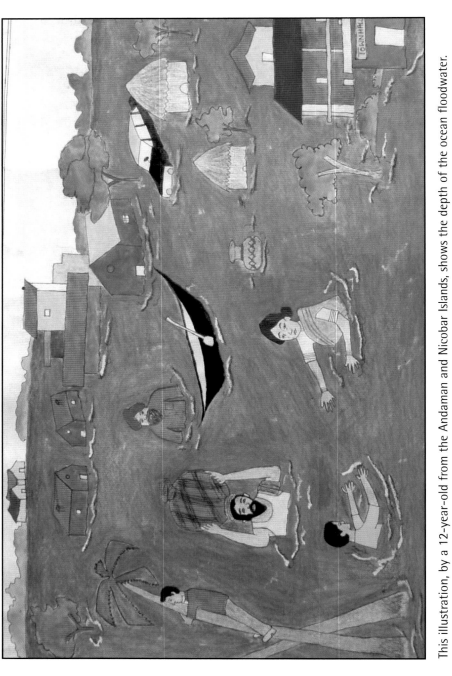

This illustration, by a 12-year-old from the Andaman and Nicobar Islands, shows the depth of the ocean floodwater. The people with outstretched arms could represent a boy being reunited with his mother.

A young boy from the Maldives drew this picture, which shows the events of the rescue operation. The picture is dominated by the blue of the ocean. The boat near the shore is flying the Maldivian flag.

These paintings, framed by a border with a skull-and-crossbones design, focus on loss and destruction. They were painted by a boy from the Andaman and Nicobar Islands.

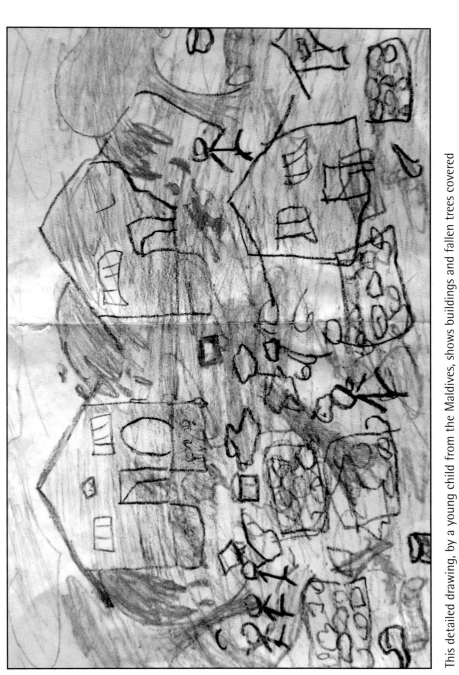

This detailed drawing, by a young child from the Maldives, shows buildings and fallen trees covered by blue seawater. Three figures sit on a tree trunk on the left-hand side of the picture.

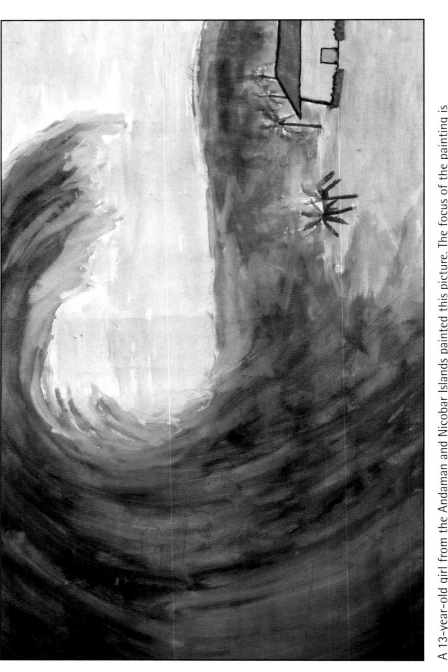

A 13-year-old girl from the Andaman and Nicobar Islands painted this picture. The focus of the painting is the huge size and dark colour of the wave, which many children who witnessed the tsunami described.

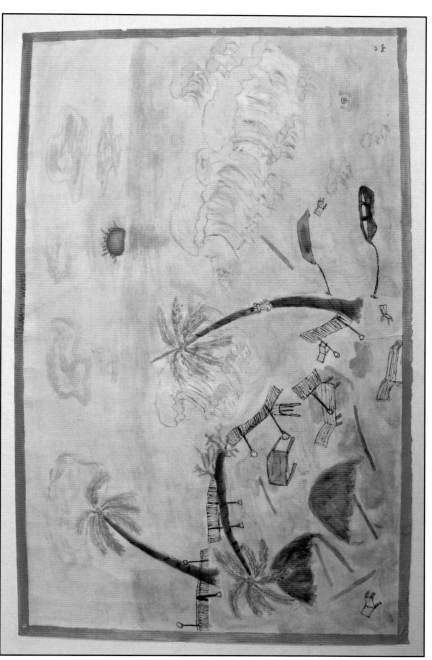

This detailed picture from the Andaman and Nicobar Islands shows uprooted palm trees and toppled sun loungers and beach umbrellas. The rising sun may have been added to indicate the time of day that the tsunami struck these islands.

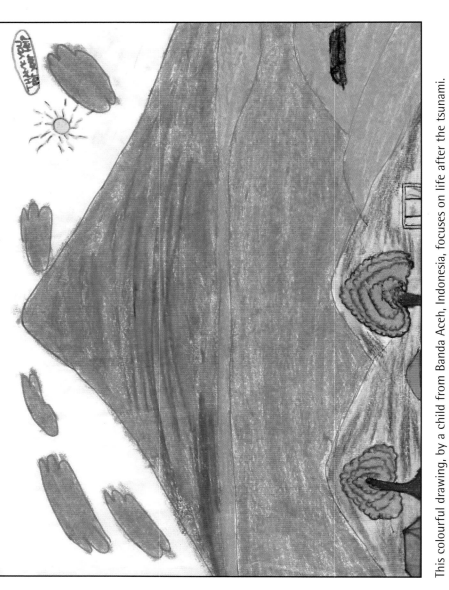

This colourful drawing, by a child from Banda Aceh, Indonesia, focuses on life after the tsunami. The sea, backed by a mountain or hill, is calm and a bright yellow sun shines in the sky.

'Uncle Vijay's spirit is in this dog! I'm sure of it!'

Vijay whined and barked. He still seemed anxious and was still trying to chase them away from the coast.

'Come on,' said the mother. 'We must go and find dad.' She picked up the youngest boy, Sanjeev took his other brother's hand, and together the family started to pick a path through the heaps of wreckage and the rivers of retreating seawater. Earlier that morning, the boys' father had gone to sell some of his catch at a fish market two kilometres inland. The mother was praying that they'd find him there.

<p style="text-align:center">* * *</p>

Sanjeev's father sat on the family's small pile of donated blankets, next to his three children and Vijay. For the hundredth time since he'd found his family staggering up the road, an intense feeling of relief and gratitude swept through him. Garbled news of the terrible wave had travelled fast and he'd been sprinting down towards the beach, out of his mind with worry, when he'd seen them. It was lucky they'd come so far to find him. Half an hour after the first wave, a second, even higher, even faster wall of water had struck the coast, killing most of those who had stayed behind and ripping the concrete buildings from their foundations. Three more waves had followed that morning, totally destroying anything and anyone left in their path.

Now, two days later, the family was in a school hall a few kilometres from the beach. The school was a temporary home for them and hundreds of other families. Sanjeev's father was getting dressed, steeling himself for another gruelling day helping with the clear-up. His wife was fetching a small box of food from the emergency supplies that were being shared out in the car park.

'Dad,' said Sanjeev, stroking the dog, 'is Uncle Vijay's spirit really in Vijay? I mean *really* really?'

His father thought for a moment before answering. His wife was absolutely convinced that this was so, that Uncle Vijay's spirit lived in Vijay and had saved Sanjeev. She had always been fond of the dog, but now she

treated him with something approaching reverence. Sanjeev's father generally liked things to be logical and provable, and was content to be grateful to Vijay for being the amazing dog he was; he wasn't sure there had to be a supernatural explanation for the dog's extraordinary courage and loyalty. But on the other hand, he was so relieved to have his family alive, he could believe in anything.

'It's true for mum,' he said. 'And she usually knows more than we do. In any case, it's a nice thing to believe, isn't it?'

'Yes,' agreed Sanjeev, 'it is. But Muthu had an uncle who died when he was little too. Why couldn't *his* uncle's spirit find a dog to be in and save him?' Muthu had been one of Sanjeev's school friends. One of many who had been killed by the tsunami.

Sanjeev's father couldn't answer his son's question. All day yesterday, he'd helped to clear the bodies of men, women, children and babies. Many were people he recognised – friends, relatives, neighbours – and their faces had haunted his dreams all night. How was it that his wife and three children were all alive, when others had lost their entire families? If you believed that the survivors were especially blessed, rescued by spirits, did you have to believe that the non-survivors had been especially cursed, abandoned by spirits?

'I don't know,' sighed Sanjeev's father, putting an arm round his son's shoulders. 'I just don't know how these things work.'

'I don't mind if I was saved by Uncle Vijay's spirit or by just Vijay,' said Sanjeev. 'But I wish something could have saved Muthu and all the others.'

'I know,' said his father. They sat without speaking for a minute.

'Anyway,' said Sanjeev, his busy mind moving onto a new thought, 'even if Vijay *is* just a dog, he wouldn't have been here to save me if Uncle Vijay hadn't saved him from the roadside when he was a puppy.'

'You're right,' said his father, thinking it through aloud. 'Uncle Vijay certainly saved you one way or another, even if it was just by being kind to a stray puppy all those years ago.'

He kissed his three sons and stood up. He would have to go out again soon. Back to the grisly and seemingly unending task of clearing up the chaos and the dead. He hadn't found any answers to Sanjeev's questions. But

maybe Sanjeev had come up with something to make life and death seem less random and meaningless and cruel. Even if dead people's spirits couldn't live on to help us, their acts of kindness could.

The boys' mother came into the hall carrying a box of basic food supplies – bananas, nuts and bread – which would just about keep the family going for another few days. The old cardboard box was too small and splitting down one corner. The father automatically started to go and assist his wife, but Sanjeev sprang to his feet.

'Let me help you, mum,' he called, running to her.

Sanjeev looked so keen, so eager to help, his father thought. So suddenly just like Uncle Vijay.

Y Care International's role in southern India
In the hours immediately after the disaster, members of the YMCA in Chennai (one of Y Care International's local partners in the affected region) played a valuable role in the relief effort in southern India. They cleared debris, found and helped survivors, and recovered the bodies of those who had been swept from the beaches just like the one that Sanjeev and Vijay were playing on. Following the tsunami, the YMCA is building houses in India and providing educational support to more than 1,500 children. It is also providing trauma counselling and therapy to children and young people who have been through so much, to help them focus on constructive, happy thoughts – and leave the disaster behind.

The Christmas Angel

CLIFF MCNISH

Christmas on a hot sandy beach – can you imagine anything better? A clear blue sky, not a hint of cloud, and just enough breeze to keep you cool while you open all those presents. Perfect.

As a special treat, Dad had booked the four of us into a luxury resort on one of Thailand's top beaches for the Christmas holidays. Me and my five-year-old brother, Jack, weren't used to comfort like this. The hotel we were staying in seemed to have everything: not just pools and water slides, but saunas, games rooms, even a private stretch of beach. It was so luxurious that when we arrived there were lotus-flower petals strewn in the baths of our rooms. At first, Jack couldn't decide whether to play with the petals or eat them.

On Christmas Day, we all went down to the beach. I still remember everything about that morning, because it was so fantastic. Jack made us all laugh – you know the way you are when you're little, so excited about your presents, tearing into the wrapping paper because you just have to know what you've got straight away? Well, he was doing exactly that, but Mum insisted on slapping sun cream all over him while he was *still opening* his presents. So there's Jack, squinting in the bright sun, with Mum holding his arms to put on the cream, and he got so annoyed with her that out of sheer frustration he started *biting* the wrapping paper off his presents. Pretty soon all these tiny bits of paper were blowing all over the beach, with me looking like an idiot, running around picking them up. Dad, meanwhile, stayed entirely cool throughout. I remember that. I can still picture him relaxing in

his deckchair, eyes half-closed, sipping a pink drink with a titchy umbrella in it, and gazing with a big grin out at the sea as if nothing was going on around him at all.

That was a good day. The next day was the 26th December.

My name is Ann, and by the end of the 27th December a lot of people were patting me on the back and saying nice things about me. I was hailed as a heroine by some friends of my parents, which was weird considering the first reaction adults on the beach had to me when the tsunami struck. One of them afterwards even went as far as to call me *The Christmas Angel*.

It took me a while to understand why so much fuss was made about what I did that day, but I think I understand now. It was because they were still in shock. There wasn't much good news coming out from Southeast Asia, and *my* little story was a snippet of happiness people could clutch onto. Over six thousand people were killed that day in Thailand. It was terrible. Even back at home, thousands of miles away, everyone was desperate for a story that wasn't about people dying. They wanted a story about people living. They wanted a story where no one on a beach died or was even seriously hurt. And I think adults also liked the idea that it wasn't one of them, not some clever man or woman, not even a tough boy dragging people off the beach, but a girl – an ordinary, eight-year-old girl – who'd saved them all.

Well, I'm that girl, but I'm no heroine. I played my part, but so did my Mum and Dad, warning the other parents, and so did all the staff at the hotel, risking their own lives to run down the beach to get everyone off it as fast as possible. I'm no heroine, and I'm no angel, either. An angel would have swooped down from the sky, collected all those people on its wings and swept them to safety. I didn't do that. I just knew something. Here's the truth about what happened.

We'd got up early that morning, around 8 a.m., so we could get a nice spot on the beach. Even so, there were about a hundred others already on the sand, mostly tourists like us, soaking in the sunshine. There wasn't a cloud in the sky. It was humid, though, and the four of us, used to cold winter

weather back home, were sweating just from the stroll from the hotel down to the beach front.

I remember thinking: I'll let myself get really hot, then go for a dip in the sea.

Jack sat there for ages, happily whacking parts of the beach flat with his spade. The rest of us were served frosted drinks – orange for me. Dad smoothed out our towels. Mum unfurled one of the hotel's huge beige beach umbrellas and dabbed some more sun cream on my ears. Everything was peaceful and calm. In fact, the sea itself was unusually calm. There was barely a ripple on it. It was only afterwards I realized that this was the first sign that something was wrong.

I was lying down, feeling an irritating trickle of sweat running under the strap of my swimsuit, when the wind suddenly shifted. Then I noticed something else: the beach had suddenly become very quiet. People had been talking, but now they'd stopped. Even Jack, who'd been chatting merrily away to an empty seashell, had gone silent.

I shaded my eyes, and followed his open-mouthed gaze out over the water.

At first, I couldn't believe what I was seeing. I thought our beach had disappeared.

Then I realized that the beach was just *bigger* than before.

It was ten times the size it had been.

The sea was leaving the shore.

It was incredible to watch. The water retreated, rushing backwards amazingly fast towards the horizon. For a moment no one on the beach said a word. We were all awe-struck. It wasn't just that the water had gone *backwards*. It was what was left behind. Dozens of sea creatures were now exposed on the beach. Tropical fish flopped around, gasping for air. Crabs and shellfish scuttled up and down the sand, looking for a place to hide.

You might have thought that everyone on the beach would be alarmed, but they weren't. What had happened was just so weird that I don't think anyone knew what to think. Little kids started to totter down the beach. The adults were equally mesmerized. Quite a few of them headed down the beach as well, to inspect all the creatures left behind.

Afterwards, I was told that shortly before the tsunami struck animals all across southern Thailand behaved strangely, as if they knew what was about to occur. Owners of elephants reported them running for higher ground. Normally obedient dogs ran out of their homes and refused to go indoors. Flamingos left their low-lying breeding grounds. Millions of other birds all across Thailand, and Indonesia and everywhere else the tsunami struck, took to the skies. In zoos, animals locked inside went berserk and nothing would calm them down.

Whatever instinct the animals had, we didn't share it. Everyone was spellbound by the retreating waters. Mum joined several other adults, taking a few steps down the wet, glistening sand. No one seemed to be particularly worried. A few parents kept their children away from the more dangerous-looking stranded creatures, but no one suggested leaving the beach.

It was then that I remembered a documentary I'd seen, showing some shaky film footage of a tsunami that had hit Papua New Guinea a few years back. I couldn't remember the details, but that had definitely started just like this – the sea retreating really fast.

For a few moments, I was too dazed by how similar this was to the disaster in the film to grasp what was happening. Then I found my voice, and rasped, 'Tsunami, tsunami.' Jack looked at me and laughed, repeating the strange word. Dad muttered 'What?' but he wasn't listening. Mum was too far down the beach to hear me. The air was very still. Then, far out to sea, the water began to swell and rise up. Everyone watched it, fascinated. Some people actually walked towards it.

I stood up and yelled out to Mum to come back.

'What's the matter?' she asked, shielding her eyes, still gazing out to sea.

'We have to get off the beach,' I shouted. 'It's a tsunami.'

She shook her head, staring at Dad as if he would understand what I was freaking out about. He shrugged, embarrassed. He spoke to another man near us. I snatched Jack up. He started play-fighting me, thinking it was a game.

'We have to get away!' I said, as loudly as possible. 'We won't have long!'

All the adults within earshot frowned or glanced sheepishly at each other, expecting one of *them* to explain what the mad girl on the beach was

so upset about. I ran down the beach towards Mum, hauling Jack with me. 'We've got to get off the sand,' I shouted. 'Why aren't you listening to me? It'll kill us all!'

'What will?' Mum held me. 'Ann, what's wrong? We don't understand.'

'The sea is rising! We've got to get away from the shore!' I was screaming at the top of my voice by now.

Jack, crying, slipped from my arms. Mum picked him up.

'The wave will kill us!' I yelled, over and over. Still no one moved. None of the adults believed I could know something they did not. I glanced out to sea, and pointed at the distant wave approaching the beach. No one understood the Japanese word *tsunami*.

'Tidal wave,' I rasped. 'Tidal wave. Tidal wave.'

And this time they understood. They knew what *tidal wave* meant. You should have seen the look of horror that came over the adults within earshot. Mum put her hand to her mouth. At the same moment a yacht way out at sea was tipped over, suddenly, violently. It looked as if the entire sea was coming out of the water. Most people were still rooted to the spot, but not Mum. She said one word. I'll never forget the way she said it. It came out like a scream, and for a moment I froze.

'*Run!*'

Holding Jack tight against her shoulder, she grabbed my wrist and we sprinted from the beach. Behind us, Dad shouted warnings to those nearby, but the message wasn't getting through. Instead of running for their lives, people started slowly packing up – putting away napkins, towels, finishing their drinks – as if there was all the time in the world! I yelled out more warnings, but most people still didn't understand, or couldn't hear me.

We rushed back to the pool of the hotel, and Dad breathlessly explained to the staff what was going to happen. And this – this – was the heroic part. Because the staff, understanding the risk, knowing that the wave might hit us at any time, and kill them if they were caught on the sand, ran out to the beach. They risked their own lives, rushed out and called out as loudly as they could in Thai and German and French and every other language they knew, telling everyone to get back to the hotel.

Mum, determined to make sure we were as high up as possible when the

wave struck, dragged me up the hotel steps to the top floor. From there we watched dozens of shouting and frightened people running from the beach. Unbelievably, some of the adults were *still* trying to tidy things away and pack up. One woman couldn't take her eyes off the ocean. I saw a boy – it must have been her son – desperately pulling her across the sand.

'How high will it be?' Dad gasped. 'Ann, how high will the wave be?'

I knew what he was asking. He wanted to know if we would be safe on the top floor.

I had no idea, but we didn't have long to wait to find out.

The first wave struck the beach only seconds after the last person made it to the hotel. I can't begin to describe to you how terrifying the wave was to watch, not because it was so big – it was only about twice Jack's height – but because it was so fast. One moment there was this wall of water frothing and bubbling out at sea. The next the wave hit the beach. The boom from it was incredible, like an exploding bomb. Later I discovered the wave struck the shore at about 800 kilometres per hour – faster than a jet aircraft. As soon as we saw what happened to the beach, we knew anyone left out there would have been killed. Sunbeds were flipped over the roof of the hotel. Deckchairs were shredded. Heavy tables, yanked from the sand, crashed into the building. Trees – not little bushes but huge, mature palm trees – were thrown into the hotel pools. Cars and vans were picked up and carried inland. Power cables were ripped out. Wooden huts were torn to pieces as if they were made of paper. We had no idea who might be inside those huts.

All of us were frozen with terror, then a few people ran around to the other side of the hotel to follow the wave. It flowed inland, carrying massive rocks and trees and boats for over a mile. Later we discovered that many local residents living outside the hotel survived the first wave, only to be pulled out to sea as the wave retreated, unable to find anything to hold onto to save themselves. We watched the first wave surge inland. Then it suddenly retreated again, almost as fast as it had come in, withdrawing like an animal back out to sea.

'Is that it?' a boy near me asked, and suddenly adults who had not been listening to me before were desperate for reassurance.

'I don't know,' I said. 'It depends on how big the earthquake was. The

second wave is usually bigger.'

'Bigger?' someone murmured.

'Is there time to get away from the shore, away from here?' a woman asked.

'No,' I said. 'We can't go back down. We have to wait it out.'

'But what if the second wave's higher than the hotel?'

I didn't answer that. I didn't need to. We all knew what would happen if the wave reached our floor.

There was roughly half an hour between the first and second wave. During that time, all the hotel staff and guests huddled together at the top of the hotel. People were in shock, and coped in different ways. Some went completely quiet; others talked non-stop. But when we saw the next wave taking shape out at sea, all the talking ended.

The second wave wasn't like the first one. That had been clean blue water, with a white, frothing top, like a surfer's wave. The second was more than three times that size, and dark. It reared up like a cobra's head out of the ocean, almost obliterating the sky, and flew across the sea towards the beach.

'It's going to kill us,' someone whispered.

'Why is it so dark?' a man asked. 'Why so black?'

No one knew. We found out afterwards that all the seabed mud from the earthquake zone was suspended in its waters. Million of tons of mud and silt. The wave was so powerful that it had managed to carry all that debris across thousands of miles of ocean.

Most people couldn't watch what happened next. The wave was almost as fast as the first wave as it rushed towards us, but much bigger, the height of a house. By the time it hit the beach it had sunk a little, but I still felt Mum's arm close around me and Jack scream as it slammed into our hotel. I've no idea how the walls took the impact. Looking around, the foundations of other buildings were being destroyed, and we saw not just cars but whole houses being carried inland this time, and twice as far as the first wave had reached.

What could we do? Nothing. We held onto each other, that's all, and prayed the building would not collapse. There were huge blasts as the wave smashed again and again into the walls and flowed around them. Then the

second wave retreated, and we breathed a sigh of relief, but it still wasn't over. For the next two and a half hours, waves bigger than the first one continued to crash around us, and all we could do was wait and hope the next wave wasn't going to be the one that killed us. During that time, it was weird, but almost all I could think about was the hotel walls. How strong were they? Were they built of cement, like our walls at home, or something softer? If one wall gave way, would all of them collapse? I became obsessed with those walls.

After it was all over, for ages we were too terrified to leave the top of the hotel. We stayed there, hoping no more waves would come, and not daring to believe we were safe. Below us, as far as the eye could see, the whole world had been completely flattened. All the buildings except for our hotel were gone. Apart from a few steel girders or telephone poles, almost nothing was still standing. Every tree, every bush, every vehicle, every single home, lay in ruins. We didn't want to look out at the destruction for long. We were afraid of seeing dead bodies. But we couldn't help looking, and hoping not to see them, and after a while something weird happened: our throats started to feel dry and ticklish, and our eyes stang. It wasn't from crying, though we'd all done plenty of that. It was from something else we didn't understand until much later. You see, the waves had carried so much soil from the ocean depths, and then thrown them into the skies as they retreated, that choking dust filled the air. There was so much of it that for several days people had to hold cloths over their mouths to breathe, and for many weeks afterwards the sun, shining though all the dust, left hauntingly dark, beautiful sunsets across the country.

*　　*　　*

Our beach was one of the few places struck by the tsunami in the whole country where no one was killed. Afterwards, my dad discovered tourists from nearby resorts wandering around like zombies. Some of them had lost whole families, lost everyone. Just a few miles away, on another beach where there had been no warning of the tsunami, most people had died.

Afterwards, as I've told you, for a while some of the adults called me

The Christmas Angel. But I hope you can now understand why I never liked that name. I wasn't an angel. I just happened to know a piece of information that helped save some lives. If you had known, you'd have done the same as me. When I arrived back home, and I realized how many in Thailand had died that day, I thought about all those who'd been lost. Did you know that more children died than adults? And very young children in particular, because they were simply not strong enough to hold onto anything when the waves struck, or were just too weak to swim for long. But many older children also died trying to cling onto their younger brothers and sisters. And many parents died too, needlessly. They could have saved themselves – many were strong enough – but they died trying to save their own children, and even other people's children. This story is for all those angels.

How children in the UK have helped
Through the first-hand experiences of the tsunami as tourists, or from watching its extraordinary devastation on television at home, millions of school children just like 'Ann', were moved to raise millions and millions for the emergency relief effort by holding fundraising events. In the UK alone, it is estimated that children have raised almost £20 million – that's a personal donation of £2 from every school child in the country – money that will help less-fortunate children all over the world smile again.

The Wave and
the Little Man

ALAN GIBBONS

If only I had come home when Hoyu[1] had told me to.

'Don't stay out too long after dark, Abdi,' she had said, as she always did. 'Remember, you're the man of the house, now that Abo[2] has gone.'

But it was such a beautiful evening in Hafun. People were sitting outside their houses on the beach. The lights shone through the dusk onto the sand. You could hear the adults talking, telling old stories. There was the crackle and smell of cooking, of beans and *canjero*. In the distance somebody was singing. You could hear his voice over the grumble of the camels and the jingle of their harnesses as they stamped across the parched yellow ground. What could possibly go wrong? Everything was as it should be.

The village smelled of salt and incense and the wind murmured over the yellow sand. It was the same, familiar world I had known all my life. I was having so much fun that evening. Surely another few minutes wouldn't matter. I'm not afraid of the dark. Not really. I was with my best friend Bashir. The game of football we'd been playing with our friends had lasted more than an hour already and none of us were the least bit tired. Every time the ball went into the ocean one of us would scamper after it, giggling his head off.

That's how it happened. I was the closest to the ball so I ran after it, skipping over the waves and shouting at the top of my lungs. Then I felt something grab my ankle. I fell heavily twisting my leg under me. I could hear the others giggling, especially Bashir. They must have thought I was messing about but I wasn't. The pain burned like fire. But do you know what

1. 'Hoyu' is the Somali word for 'Mama'.
2. 'Abo' is the Somali word for 'Papa'.

made me fall? A stupid bit of seaweed, that's all. I got tangled up in it and twisted my ankle. I made one silly mistake and it was to cost me. Man of the house? Who was I kidding?

All the way home my heart was thumping. Hoyu was going to be angry. With Abo gone, she has enough to do taking care of me and my baby sister, Kalifa. She is strong though, as strong as our concrete house. The other mothers tease her for being much younger than them, but she's twenty-one years old – more than three times older than me! And like a proper grown-up, she always knows what to say, what to do. Or she did. Until the water came.

But, as I hobbled home that night, I knew nothing of the danger out at sea. All I could think about was the pain in my foot. I felt so stupid. Our house sits on the beach. As I got nearer to it, I could smell the spiced tea and I could see the lights glowing from the windows, which looked out over the dark sea. As I reached the door, I tried my hardest to disguise my limp but every time I put my weight on my foot I winced. Crazy, isn't it? A little thing like a piece of seaweed and I could hardly move. I didn't feel like the man of the house at all, just a silly boy.

'Oh Abdi, what have you done?' Hoyu sighed.

When I explained, she put Kalifa down and examined my foot. Her fingers felt cool and comforting on my skin. But when she touched my swollen ankle I sucked in my breath.

'That hurt, didn't it?' Hoyu said.

I nodded.

'You'd better go to bed,' Hoyu said, stroking my hair. 'Try to get some sleep. We'll see how you are in the morning.'

But she never got to ask how I was, not the next morning or any other. The water came. Even then, as I laid my head down, the danger was approaching. It was just hours away and none of us knew a thing about it.

'Goodnight, Hoyu,' I said.

'Goodnight, Abdi,' she answered. 'See you in the morning.'

I lay in bed, listening to the gentle crashing of the waves on the beach. As the ocean murmured, I drifted away to a land of peace where my foot didn't hurt and I could stay out as long as I wanted. In my dreams I saw the

dusty, yellow village and the dark blue ocean. There aren't many colours in my village but there are colours in my dreams. Even when I started to wake the next morning, I was still floating somehow, bathing in golden sunshine, looking down at brilliant blue seas. Soon I could feel the pain starting to gnaw at my swollen ankle and teasing its way through my dream but I didn't try to get up. Hoyu hadn't called me. She was busy with Kalifa. I could just lie back and doze. Everything was still. I was happy.

That's when Hoyu's yell pierced my thoughts. She ran into the bedroom holding Kalifa, screaming at me to move.

'Abdi!' she cried. 'Get out of bed.'

For a moment or two I stared at her, hardly awake.

'Now!' she yelled.

I'd never seen her like this, so scared, so angry. Yet she wasn't angry with me. I couldn't work out what was going on. Hoyu was shrieking with fear and pleading with me at the same time. Her mouth shouted and her eyes begged. It made me confused and scared.

'Abdi,' she was shouting, 'pick yourself up.'

'But I can't, Hoyu,' I stammered, 'I've hurt my...'

And then I saw it. Or did I hear it first? There was a sound like an aeroplane crashing or a huge monster falling to the ground, a great, wet roar exploding from its throat. Then a wall of water was hurtling from the ocean towards the beach, towards our house. I couldn't take my eyes off it. I just stared out of the window. The ocean seemed to be boiling, bubbling, white froth surging up as the wave rushed closer. It was almost beautiful, I think now. Almost. But something so savage and angry can't be beautiful.

'Abdi,' Hoyu cried, 'I can't carry both of you. Move!'

I'd never seen her like this. She always knew what to do. She was always there to make things right. But that day she needed me to make things right. I could see the agony in her eyes. I'm the man of the house now, I told myself. I must behave like one.

'Go!' I shouted to her. 'Take Kalifa!'

I swung my legs out of the bed. But as soon as my feet touched the cold stone floor though, a shock of pain exploded through me. My legs gave way and I crumpled to the floor. By now, seawater was seeping through the

doors, the same foaming, frothing water I had seen boiling from the ocean. My clothes were damp and I was trembling.

'Abdi!'

Hoyu was frozen, staring at me. I could see the whites of her eyes, the staring horror she couldn't hide. She was frightened and uncertain. Just like me, just like a child. But you are twenty-one years old, Hoyu, I wanted to say – just like a proper grown up! I never really believed the other mothers who teased mine about her age. Until now. My mother always knew what to do. But now, she needed me to help her.

'I'll be OK,' I said. 'Go. GO!'

Hoyu squeezed her eyes tight, as if she was trying to shut out the world and the terrifying wall of water that seemed to enclose the house on all sides. Or was it the sight of me, crumpled on the floor, that she was trying to shut out? Without another word, she ran out of the house with Kalifa and disappeared into the booming, swirling waters.

I was alone.

The wave was all the way up the beach. Suddenly I was waist-deep in water. This was my first test of manhood and I was determined to pass. I began wading through the water. It was as if my legs themselves were dissolving, becoming part of the swirling torrent. Driving myself forward in spite of the pain, I half-stumbled, half-splashed towards the door. Finally I found myself clinging to the doorframe. That's how I stood for a moment: alone, vulnerable, afraid, while the waves hugged my waist, crushing my stomach.

Suddenly I was as angry as the furious black waves. As I clung to the doorframe, digging my nails into the concrete, I felt a pain greater than the one in my foot. It was the pain of never seeing Hoyu again. Through blurred eyes, I could see her in the distance, racing towards the high ground with Kalifa tucked under her arm. Maybe it was the splashing water. Maybe it was tears. Either way, she was no more than a hazy figure melting into the distance.

'Hoyu!'

Determined not to give up, determined not to make her cry for me, I forced myself forward. Now, instead of the stone floor, there was sand

beneath my feet. Though it was pounded by seawater, at that moment, as I stood on it, I felt safe. I was going to make it. Wait for me, Hoyu, I thought, I'll see you on the higher ground. Please, just wait for me there. Then the roaring wall of water took me. It reached from the roof of the sky to the depth of the earth. It bellowed. It filled my mouth, my ears, my nose. Mighty fingers were crushing the life out of me. Finally, it smashed against me and filled my eyes with darkness. The world slipped away and I could feel no more.

* * *

I live in a peaceful place now, above everything, on ground higher than anywhere else. From there, I look down on the ocean and it is always gentle, as if apologizing for the rage that took so many lives. I go down to the beach sometimes and, invisible, I walk among the people. In the first days after the water came I felt so sad. I could hear women and children crying. For as far as the eye could see everything was flat. A tree here, a shattered wall there, that was all that was left standing.

That is beginning to change at last. The people are trying to put their lives back together. Sometimes I spot my old friend Bashir among them, sliding down a hill on a flattened plastic container and giggling the way he always did when he was with me. I want to join in but I can't do that any more, not since the waters came. Bashir stops occasionally and looks in my direction, as if he can see me or hear me breathe. But I know that's impossible. The moment passes and he races back up the hill to play the game all over again.

There are times when I return to my family to see how they are doing without me. I look at little Kalifa and imagine I can see the future in her young eyes, the happy life she will lead, the children she will have. She will even grow old one day, something I will never do. You never know, she might remember the tales Hoyu has told her about me, how I was the man of the house, how I was so brave. She might tell those tales to her children. Who knows? She might even call her son Abdi.

Once I sat down beside Hoyu and watched her looking down at the

beach, at the spot where our house once stood. I knew she was thinking about me, wondering if she could have done anything different. You couldn't, Hoyu. The wall of water was stronger than either of us. So, don't blame yourself. Don't be sad. You made the right choice. You should be proud. I am. Because of you, I have passed my test of manhood. I look forward to seeing you again one day, Hoyu. Maybe we will even talk together. See you on the higher ground.

SOS Children's work in Somalia
SOS Children have been working in Somalia for more than twenty years, helping orphans and single mothers like the young mother of the 'real' Abdi. The charity has built a village in Mogadishu, the capital of Somalia, and people come from all over the country for the unique aid and assistance it provides. At the Mogadishu Village there is a nursery, a school, a youth facility that trains nurses, a mother-and-child clinic and a medical centre with a maternity ward – many of these facilities are the only ones available in the whole country. Here, SOS Children provide Somalis like Abdi's mother and sister with the medical care and moral support they need after surviving a disaster like the Boxing Day tsunami.

THE WAVE AND THE LITTLE MAN

Washing the Truck

STEVE VOAKE

'I am not washing that,' said Priya, throwing the sponge up against the blue sky so that droplets of water spun off it like diamonds. 'No way. It's filthy!'

She batted the sponge across to Prakash, who caught it and rolled his eyes as water spattered all over his purple shirt.

'Of course it's filthy,' he said. 'That's the whole point.'

'Alright then,' said Priya. '*You* wash it. And don't forget your inhaler. You'll need it by the time you've finished.'

It had been Prakash's idea to come down and wash a few cars, and Priya had to admit it wasn't such a bad one. The beach was always busy on a Sunday morning as families came together at the end of a long week, and the parking lot was already filling up with cars. Watching the sunlight sparkle across the water, she saw groups dotted everywhere across the sand, playing cricket, strolling by the water's edge or simply sitting and enjoying the morning sunshine. A little girl in pink plastic sandals skipped past, singing softly to herself as her mother waited patiently for her on the warm sand.

Picking up her yellow bucket, Priya watched Prakash saunter across the beachfront to where the big white rubbish truck was parked, sucking on his inhaler as he went. The fact that he was ten years old meant that she sometimes treated him like a little brother, but the three-year age difference had never stopped them being friends. There was something about his spirit that lifted her own, and although his asthma made him frail at times, she had never known him give up on anything.

She could see that the truck would be no exception, despite the fact that it would be at least a half-hour job. Not only was it huge, but it was also covered in a thick layer of dust and grime. They could easily wash four cars in the time it would take to clean it.

But Prakash was not going to be put off.

Watching him knock on the driver's door and start his negotiations, Priya shook her head and smiled.

They were going to need plenty of water.

Pulling on the handle of the water pump, Priya noticed a line of ants crossing the road that led away from the beach and wondered if there was going to be a storm. She had heard that ants often swarmed in thundery weather. But the sea was as blue as a sapphire, and the sun shone from a cloudless sky.

It was a beautiful day.

Picking up the bucket of water, Priya began to walk towards the truck. She was about to call out to Prakash when somewhere, somebody screamed.

Puzzled, Priya stopped and put the bucket down. Water slopped over the sides, soaking into the sand with a hiss.

'What is it?' someone shouted.

Priya couldn't see Prakash anywhere now. She ran across to the truck and called up to the driver.

'Hey mister! Have you seen Prakash?'

But the driver was leaning out of the passenger window, staring at something on the beach.

'Prakash?' called Priya.

Then she walked around the back of the truck to see what the fuss was about.

The huge green wave barrelled up the beach towards her and as she turned to run a dark wall of water rolled into the parking lot, hitting her with such force that it knocked her off her feet, slamming her into the side of a car before surging past into the road beyond. Fighting her way back up to the surface, Priya felt the car lurch sideways and somehow managed to grab hold of the door handle with her left hand. Gasping for breath, she looked around to see that the water was already receding, swirling back on itself and

sucking everything down onto the beach once more. As the strong current pulled at her legs, she tightened her fingers around the door handle and cried out in alarm, terrified that she would be swept out to sea. Clinging on with all her strength, she saw her yellow bucket float past on a twisting river of splintered wood and rubbish.

Floating next to it was a pink plastic sandal.

As the water surged back toward the beach, the flood level dropped and Priya released her grip on the door handle, splashing frantically through the retreating current in search of her friend.

'Prakash!' she called. 'Prakash!'

At the edge of the parking lot, she stopped and stared in amazement.

Nearly all of the fishermen's huts that lined the fringes of the beach had completely vanished. Of the few that remained, most had been torn and splintered into strange, jagged shapes, their insides ripped out and strewn across the wet sand, scattered and mixed with all the other bits of rubbish that the sea had cast aside as it rushed back towards the horizon. Retreating further and faster than ever before, it left behind a vast expanse of beach that was normally hidden beneath the waves.

Priya stared at the bundles of coloured cloth twisted untidily across the beach and realised that she was looking at dead bodies.

Strands of steam rose like ghosts from the damp sand. The air was heavy and smelled of salt and oil.

Stepping forward as if in a dream, Priya made her way across the sand and saw how the sea had left its treasures amongst the debris. Huge purple jellyfish the size of dinner plates glistened and cooked beneath the fierce sun, a tangle of tentacles spread around them like silver ropes. Bright fish flapped in shallow pools, their mouths opening and closing in the heat as metallic-green flies crawled across their shining scales.

Priya thrust her knuckles in her mouth in an attempt to stop herself from crying.

It felt like the end of the world.

'Mama,' cried a little voice next to her. 'I want my Mama.'

Priya looked down to see a little girl crouching on the sand. She was

soaking wet and her yellow dress clung to her as she shivered and hugged her knees against her chin.

Priya knelt down and stroked her head.

'It's alright,' she told her. 'Everything will be alright.'

The little girl's bottom lip quivered and Priya recognised her as a young pupil from her school. She couldn't have been any more than five years old.

'My Mama's gone,' she said.

Priya held out a hand and helped her to her feet.

'What's your name?' she asked.

'Lalita,' replied the little girl.

'Lalita,' Priya repeated. 'Well, Lalita. I'm going to help you find your Mama. OK?'

'OK,' said Lalita. She squeezed Priya's hand and put her thumb in her mouth.

Priya squinted into the sun and scanned the beach. People were beginning to move now, some shuffling aimlessly about, others bending down to look for loved ones.

The beach was strangely silent, as though the world was holding its breath.

In the distance, next to the splintered remains of an upturned fishing boat, Priya spotted a smudge of purple on the sand.

She stopped and raised a hand to her forehead, shielding her eyes from the sun.

As she watched, the purple smudge got up and headed off down the beach. *Prakash.*

'Come on, Lalita,' said Priya. 'Come with me.'

'Is it Mama?' Lalita asked. 'Have you seen her?'

'No,' Priya replied, quickening her pace. 'Not yet. But we'll find her soon. Don't worry.'

As they padded across the wet sand, Priya noticed an old woman lying on her back. She had one arm stretched up toward the sky.

'Wait there,' Priya told Lalita. She knelt down next to the woman and took her hand in her own.

'Are you hurt?' she asked.

'The sea,' whispered the old woman. 'It has taken everything.'

Priya nodded. 'I know,' she said. 'I'm sorry.'

'It will come back again,' said the woman. 'The sea will come back.'

Priya patted her hand. 'I'll get help,' she said. 'It will be alright.'

But when she looked into the old woman's eyes she saw that they had clouded over, and knew that the life had gone out of her.

As she covered her face gently with a piece of cloth, a small hand touched her on the shoulder.

'Is she sleeping?' Lalita asked.

'Yes,' said Priya. 'I think so.'

They hurried away across the sand and as they reached the broken fishing boat, Priya cupped her hands around her mouth and shouted, 'Prakash! Prakash!'

The purple smudge stopped and looked in her direction.

'Prakash, over here! It's me, Priya!'

Clutching Lalita's hand, Priya ran to meet Prakash and as she approached she noticed a small boy standing next to him.

'Look who I found,' said Prakash breathlessly. 'It's Nirav. Can you believe it? He got washed off the parking lot, same as me.'

Priya nodded. 'Are you OK?'

Prakash shrugged. 'A few cuts and bruises. How about you?'

'Better than some.'

A small, dark-haired girl of about two wandered past them, crying loudly.

'Hey now,' said Prakash. He bent down and swung the toddler up onto his hip.

Priya noticed that people were starting to run past them, away up the beach.

'Hey!' shouted Prakash, lifting the small child into the air. 'Whose little girl is this?'

A young woman rushed up to him and snatched the little girl from his grasp screeching, 'Nivedha, Nivedha, where did you go?' before hurrying away up the beach.

'You're welcome,' said Prakash. 'Don't even mention it.'

A large middle-aged man in swimming trunks pushed past, wheezing loudly.

'Get out of the way, you fools!' he said angrily. 'Do you want to die?'

People were shouting now, starting to panic. A woman screamed.

'What's going on?' said Prakash.

Priya looked down the beach and saw a thick, dark line across the horizon. It was as though someone had taken a ruler and drawn along it with a black pencil.

'Oh no,' she said softly. 'No.'

'What is it?' asked Prakash. 'What's the matter?'

'Look,' said Priya, remembering the old woman's words. 'The sea. It's coming back.'

Prakash turned and saw the dark wall of water racing up the beach towards them at incredible speed.

'Go!' he screamed, grabbing Nirav roughly by the hand. 'Run!'

Gathering Lalita up in her arms, Priya put her head down and began to run blindly up the beach. She heard her breath rasping in her throat and the roar of water behind her. Up ahead, people were screaming, running from the parking lot. A man raced past her, clutching a beach umbrella. She was only yards away from the cars now.

'Come on come on come on come on,' she urged herself.

The white rubbish truck was right in front of her. She could see the sunlight glinting off its chrome bumpers.

Just two more steps…

The wave struck her like a sledgehammer, smashing her down and hurling her against the side of the truck. She was flung sideways, tumbling and turning as the force of the water cracked her head against a wheel and dragged her left arm beneath the vehicle. Somehow she managed to keep her free arm gripped tightly around Lalita's waist as they were sucked right underneath the truck, down into the dark whirlpool that churned beneath it. Desperately kicking her feet against the wheel arch, she emerged from the other side and managed to grab the metal step that led up to the driver's cab. She pulled Lalita's head clear of the water and, using all her strength, pushed the little girl up onto the step.

Lalita hesitated and looked back.

Priya knew that if she slipped she would be lost forever in the raging waters.

'Get inside!' Priya screamed at her. 'Now!'

With a sob, Lalita disappeared through the open window of the truck and Priya grabbed the door handle, pulling herself up and throwing herself on top of Lalita, who was crying loudly.

'Hush,' Priya told her. 'You're safe now.'

Water poured through the doorway on the driver's side, and Priya hurriedly picked Lalita up and dumped her unceremoniously onto the back seat.

'Stay there,' she instructed her.

Then she heard a voice.

'Priya! Help!'

Grabbing the steering wheel with one hand, she scrambled across the driver's seat and leaned out through the doorway. She saw Prakash hanging onto the tailgate of the truck. Nirav clung desperately to him, his arms wrapped tightly around his waist as the waters rose.

'Climb up!' Priya shouted. 'Climb into the back!'

'I can't!' Prakash shouted back, his eyes wild with fear. 'He's too heavy!'

Priya looked at the brown water swirling fiercely around the truck.

'Hang on,' she called. 'I'm coming.'

Placing one hand on the edge of the doorway, she swung out above the water and grabbed the side of the truck with her other hand. She edged along until she reached the tailgate.

'Give me your hand!' she shouted. 'Quickly!'

Prakash reached up and grabbed her hand, but as she pulled him up his foot slipped and splashed down into the water. Shrieking with fright, Nirav slid further down his waist, clutching at Prakash's shirt and ripping the sleeve. Feeling as though her arm was about to be torn from its socket, Priya braced herself against the truck, gritted her teeth and pulled with all her strength. As she cried out, Prakash scrabbled his way up next to her with Nirav still hanging onto his tattered shirt.

Grabbing Nirav by the scruff of the neck, Priya dragged him back along the side of the truck and shoved him through the driver's door before turning back to help Prakash. With a last effort, she swung him round into the cab where he fell gasping and wheezing onto the front seat. Priya climbed in beside him and searched for his inhaler, but there was no sign of it.

'It's alright,' she said, patting him gently on the shoulders and watching the fast-flowing waters sweep a car past the windscreen, sending it tumbling down onto the beach. 'Take deep breaths. You'll be fine.'

In the back seat, Lalita was crying loudly and Priya held out an arm to her.

'Come here, Lalita,' she said as the frightened child put her arms around her neck. 'It's all over now.'

'Are we safe then?' asked Nirav nervously.

Priya stared through the windscreen and saw that the flood was beginning to drop. The waters were returning to the sea.

'Yes,' she said. 'I think so.'

For a few moments, the only sound was water, swirling around their feet and draining from the cab.

Then, quietly and without fuss, Priya covered her face with her hands and began to cry.

Prakash watched her for a second or two, got unsteadily to his feet and leaned out through the doorway. Then he clambered back in again and slapped the dashboard angrily.

'I'll tell you something,' he said. 'When we find that driver, he's going to pay us fifteen rupees.'

Priya brushed away her tears with the back of her hand. 'Prakash,' she said, 'what are you talking about?'

Prakash put a hand on her shoulder and leaned in close.

'Take a look for yourself,' he said.

Then he took a deep breath and, as he put his head in his hands, Priya saw that he was crying too.

'This truck has never been so clean,' he whispered. 'It's spotless.'

Emergency aid in southern India

Many children were orphaned that day on the beaches of India. Immediately after the disaster, SOS Children set up thirteen emergency camps in southern India, taking in almost 6,000 orphans, just like the 'real' Lalita and Nirav. Some of these camps were in temples, churches and mosques that were largely undamaged by the tsunami. SOS Children provided the children with food, clothes and medical care. To help them overcome the trauma of losing their parents, the aid workers painted, drew and sang songs with them. Progress is very slow, but it is happening. Gradually, because of the work done by charities such as SOS Children, India's tsunami orphans are coming to terms with their experiences and are growing happier.

Praveen and the Coconut Palm

NICK GIFFORD

It was another clear morning, the sky's flawless blue mirrored in the flat sea below. Praveen turned away from the sea, as it only reminded him of his punishment. He did not want to think about the sea today.

He sat on a ridge of white sand, his back against the gnarled trunk of a coconut palm. In one hand he had a half-eaten hopper, a kind of folded-up pancake crammed with yoghurt and honey. In his other hand he had a stick, which he dragged from side to side, making lines and waves in the sand.

He should be sweeping the floor at home – part of his punishment. The yellow-brown dust was getting everywhere now that Sri Lanka's monsoon season was well and truly over.

He looked out to sea again. He could see the mast of one of the village boats. Uncle Rajan's boat didn't have a mast. No need for a sail when your boat is powered by an outboard motor. Praveen loved going on the boat with his uncle, taking holidaymakers out to the reef where they could put on their snorkels and swim around.

They would be out there now. But instead of Praveen entertaining the westerners with his stories and jokes, it would be his younger brother Sanath. All because of a stupid coconut.

Yesterday – Christmas Day – Praveen had been aping around behind his father's stall by the entrance to the hotel. He had taken a paper bag, blown it up and twisted the top so that it was inflated like a football, and kicked it about with a bare foot. His twelve-year-old sister, Mayura, had been

watching. 'Hey, Prav, let me have a go. Go on!' she called.

She had been annoying him all afternoon, so he shook his head and sat back down on the bench by the stall.

Praveen never could resist the urge to play around and fool people, and he would be the first to admit that sometimes he got carried away. And now, once again, his mischievous streak got the better of him. Out of sight of his sister, he took a coconut from the stall and put it in the paper bag. Then, turning, he casually placed it on the dirt. He glanced at her, smiling, and pretended to be about to kick it. But Mayura got there first.

The noise she made!

As if she had never stubbed a toe before.

It would have been okay if she hadn't made quite so much noise, but her wailing brought their father back from across the road, where he had been talking to the owner of the trinket stall.

Their father was a short man with a great big rice belly, and even though he had to look up at Praveen, he was still terrifying. Praveen bowed his head and accepted the telling off, biting his lip when his father went on to say, 'And you will not go out with your Uncle Rajan until you have mended your ways. Do you hear? You keep playing these tricks on people. I will not have such childish behaviour from my oldest son.'

Now, Praveen stood up.

He should go back to the house. He did not want to disappoint his father any more than he already had.

In the tree above him, a flock of babblers and parakeets filled the air with their harsh chatter. He glanced up, wondering what had disturbed them so.

In the village, it was just a normal day. He could see and hear people singing and laughing, strolling and holding hands. A small group of women talked animatedly outside the temple. In the square, a group of children played cricket, using a mango seed for a ball. Off to his right, he could see the hotel compound where the first of the holidaymakers to rise were lying on loungers around the pool. Their pink bodies looked like the sausages the hotel sometimes cooked on the huge barbecue grill.

He ate the last of his hopper, vaguely wondering what it was that had

just struck him as unusual.

The dogs.

Usually there would be scrawny stray dogs wandering about the village, looking for scraps of food, but today… none.

He glanced back towards the sea once again, still longing to be out in his uncle's boat. His favourite thing was diving from the boat and then floating on the surface with his head down, staring at the coral.

There was something strange about the horizon, but he couldn't quite work out what it was. He saw the mast again… and then, suddenly, it was gone, as if it had somehow toppled over.

He continued on his way.

He spotted Mayura playing finger games with their little brother Sinniva. He cursed under his breath. She would almost certainly tell their father she had seen him out in the village when he should be doing his chores.

She had seen him so there was no point avoiding the two of them now. Praveen sidled up behind Sinniva and tweaked his ear.

Just as the little boy yelled, Praveen realised that something was wrong. He could hear a low rumble, as if the Earth itself was groaning. He turned, and saw that the horizon was too close, the sea too dark, and the rumble was now a roar that was getting steadily louder.

'The… sea!' he cried, just as Mayura shouted the same thing.

He heard a scream, men shouting, elephants trumpeting somewhere in the distance. He grabbed Sinniva's hand and swept him up into his arms.

Praveen didn't understand. What was happening?

The sea rushed up over the white sand of the beach, a wall of black, flecked with angry grey foam and easily as high as the houses around them.

He grabbed Mayura's hand just as the water hit them. It knocked the air from his lungs, and when he tried to breathe his nose filled with water. He began to choke, but with his next ragged breath he managed to suck in some air. Then, coughing and spluttering, he struggled as his body was thrown about in the mighty wave.

It felt as if he was being pulled apart, great hands tugging at his legs and arms. The water tasted of salt, but also of dirt, reminding him oddly of the time his friend Ranasinghe had made him eat mud after his joke on the older

boy had misfired.

He had lost his grip on Mayura, but he still had an arm around Sinniva, crushing the small boy's ribs in his tight embrace. As they surfaced, he saw the look of terror in his brother's eyes, and that spurred Praveen into action.

He looked around.

The water heaved and seethed, and it was full of wreckage – timber from broken buildings, uprooted trees, people...

He grabbed a frond of a coconut palm and hauled at it. The tree was floating as the wave carried them all inland. Steadily, Praveen managed to drag himself and his brother into the palm's green embrace.

He was exhausted. And hurting.

'Take hold of the tree, Sinniva,' he managed to croak, but the boy just stared at him, struck dumb by this sudden up-turning of his world.

Praveen tried to lift the boy into the branches, but his strength was not enough.

'Sinniva, over here! Come to Mayura!'

It was Praveen's turn to stare. His sister was clinging to the trunk of the tree, like a soaking-wet monkey in a world abruptly tipped on its side. She held out a hand towards Sinniva. After a moment, the boy took it and Praveen felt the weight in his arms ease. He clung to the foliage, gasping for air.

'Come on, Prav, you too.'

He looked at Mayura. She was straddling the tree, her legs in the water. She was clutching Sinniva to her chest.

Praveen took a deep breath and pulled. He did not think he had the strength in his arms, but somehow he managed to heave himself up onto a kind of platform made from the tree's fronds.

He rolled onto his back. The sky was still a perfect blue. Where had all this water come from? There had been no storm. He sat, and looked around. The sea was everywhere now.

The sea...

'Sanath!' he gasped.

He had remembered Uncle Rajan, and his brother Sanath, who had gone out to the reef in Praveen's place. What had a sea this angry done to their boat, to all the boats?

Suddenly grief-stricken, Praveen put a hand to his head, then pointed towards the sea. 'Sanath...' he sobbed. '*I* should have been out there, not little Sanath.' Mayura put a hand on his shoulder, and he saw that she was crying too.

Praveen looked down. 'I will never trick people again,' he said in a low voice. 'Never.'

Their uprooted tree drifted through what remained of the village and finally halted against a building, or rather the rooftop of a building – the rest of it was below water.

Around them, Praveen started to hear noises other than the angry churning of the water and its debris. People's voices, shouting and crying, wailing and sobbing and groaning. His own voice was one of them.

'Come on,' said Mayura. 'Let's get off this thing.'

Praveen looked up just as his sister and brother scrambled off the tree and onto the flat rooftop. There were other people there, maybe ten of them. They were holding each other, their voices part of the general cacophony.

Climbing onto the roof, Praveen saw that his father was one of these people. Normally such a proud and strong man, now he looked like an empty shell. His eyes stared, his mouth hung slack and his eyes brimmed with tears. His sarong was ripped so that one scrawny leg was visible, and he held a damaged arm close to his chest. He responded, as Mayura and Sinniva went to him, but still mumbled the name *Rajokshana* – their four-year-old sister – over and over again. 'I had her,' he said. 'In my hand. I tried to hang on, but then...'

Praveen's mind could barely keep up, after that first struggle simply to survive. His father, Mayura and Sinniva were here. Rajokshana was... gone. That still left their mother, and their younger brothers Theelepan and Duminda. And Sanath and Uncle Rajan, of course... Out there, somewhere.

The village around them was beneath water. Praveen struggled to work out which building they were stranded on. There should have been other buildings around them surely, but all he could see was the roof of the temple over to the right, and to the left, the square block of the hotel. Everything else seemed to be submerged or washed away.

Between this roof and the hotel there was a channel of seawater that had once been the road. A mass of wreckage was clogging it up, so that in places you couldn't even see the water beneath. There were people on this debris, scrambling across towards the hotel. The hotel was four storeys high – much higher than their own rooftop island – and there were people on its roof, high above the dark grey water.

Praveen stared out to sea, desperately hoping to see the shape of his uncle's boat – perhaps Uncle Rajan and Sanath might somehow have ridden out the big wave?

And then he saw that the horizon had changed again.

He shook his head, thinking his senses were playing tricks.

An angry band of grey foam cut across the horizon.

He clutched at his sister.

'Again...' he said. 'It's coming again!'

Voices around him cut off as he spoke. He raised a hand, pointing. The wave was coming again, and this time it looked even bigger.

He looked down at the water surging around their rooftop. Another wave would sweep right across this roof. It would almost certainly kill them all.

He eyed the raft of debris between them and the hotel. He had seen people scrambling across there to safety. He gestured. 'Across here,' he said. 'We have to get across to the hotel!'

'No.'

His father.

Praveen looked at him, seeing the energy returning to his father's features, the anger. 'No,' his father said again. 'This is not the time for your foolish trickery, Praveen. Don't you realise we have lost everything? Do you think this is the time to be joking around?' He waved towards the sea. 'There is nothing out there now.'

Praveen's mouth fell open. He didn't know what to do. He had to convince them, but he saw the looks on other people's faces. They would rather believe his father than him.

Then a girl's voice cut through the rising babble of voices.

'No,' she said. 'My brother would not trick us. Look! Can't you see?'

Mayura had Sinniva by the hand and now she scrambled down onto the

coconut palm again, and stepped across onto the floating timbers of a wrecked building.

Others followed, and finally Praveen and his father.

It was only a short distance across what had been the road to the hotel, but the raft of debris shifted with every step. All the time, Praveen was aware of the wave racing towards them.

About halfway across, Praveen slipped, and one leg plunged deep in the water. His father helped him up, and the two staggered forward onto the roof of the hotel's minibus.

Praveen's head spun with fear, but they had to keep moving.

The hotel was so close now. A window in the wall, glass smashed, hands reaching for him, the roar of the approaching wall of seawater…

Someone hauled him through, and in the gloom inside he saw a streak of blood across his arm where a shard of glass from the window had slashed him.

The roar outside was deafening.

He grabbed his father's arm and ran through what had been a bedroom, to the door, the corridor.

The water was around their ankles, their shins, their knees. Praveen followed a fleeing man through a door – a fire exit – to a stairwell. Below them, the stairs were a swirling black mass of water, rising rapidly.

They climbed up and eventually Praveen was in bright sunlight again.

He leaned on a wall and stared out across the churning black waters that now submerged his village. He could not see the rooftop where they had sheltered before. Even the raft of debris they had so recently crossed had been torn apart by this new wave of seawater.

Mayura was with him, and Sinniva, and their father too. They clung to each other and stared in silence.

Praveen thought about the size of the wave. It could not be just their own village that it had submerged. The next village, a couple of miles up the coast – that must be affected too. And the village after that? Other towns and villages too? It was not just his family and friends affected, but their friends and relatives too, and *their* friends and relatives. How many? He shuddered to think.

His knees were suddenly weak, his head churning like the angry water all around them. He had to sit, he had to... He sensed darkness rising around his battered body and, exhausted, he blacked out.

<center>

*　　*　　*

</center>

On another day, not too long after that awful day of what Praveen learnt to call the tsunami, he stood in what had been the village square with his father, his sister Mayura, and their three younger brothers, Sinniva, Theelepan and Duminda.

A few walls still stood, but all that remained of most of the buildings was the debris of rubble and timbers strewn across the land for miles about. The temple stood, although it was unsafe to enter. And the hotel, although that too would probably have to be demolished.

The air was damp, but there was dust in it, enough to irritate the throat and nose. There was a smell in the air too – wet earth, but also... Praveen tried not to think about what else gave the air its ghastly, sickly smell.

They had been reunited with Theelepan and Duminda two days after the wave, but there had been no sign of their mother, their sister Rajokshana, of Uncle Rajan or Sanath or many others of their family and friends.

But they were luckier than some. They had family inland and soon they were going to join them. Others, they knew, were living in huge temporary camps. But the six of them had decided to come to their home village one more time.

Now, Praveen and Mayura walked towards one of the few things remaining upright, a coconut palm. It might even have been the palm Praveen had sat against on the morning of the tsunami.

The tree had been battered, and most of its foliage had been ripped away, but it still stood. Praveen stared at it for a long, long time. He felt like that tree.

Praveen and Mayura look to the future

In the days after the disaster, Handicap International treated many Sri Lankan children like the 'real' Praveen and Mayura. In the first two months, the charity's aid workers travelled around 91 camps that sheltered displaced people, running mobile nursing teams, which gave priority treatment to vulnerable people such as these child survivors. 'Praveen' and 'Mayura' are still living with their two younger brothers and their father in a tent in the relief camp. They miss their mother, brother and sister very much. With help, the family is hoping to move soon from the relief camp, which is set up in a field, to a permanent house. The family is looking forward to a new beginning.

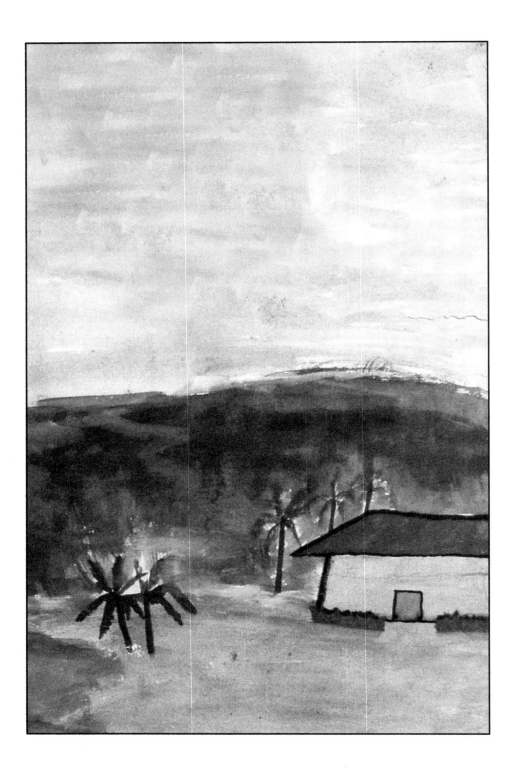

Nala's Nightmare

MELVIN BURGESS

Sunan was woken up with a start by the most awful noise, full of grief and fear. He lay there frozen in terror for a moment, waiting for it to stop. He was dreaming, surely. He'd never heard anything like it.

Then he realised what was going on. It was Nala, his elephant. She was making the most strange noise – like groaning, rumbling, panting and screaming all mixed up into one. Sunan cursed and jumped out of bed. She'd never made a noise like that before. Just his luck – the first time his father trusted him to look after her on his own and she goes crazy. He'd get beaten to shreds if anything happened to her.

Sunan ran outside to where Nala was tethered. The huge animal was swinging from side to side, moaning and wailing in an extraordinary way. The sun wasn't up yet – it was that early – and in the darkness, she looked like a monster. Sunan flung himself at her and grabbed hold of her trunk.

'What's wrong, Nala, what's wrong? Don't tell me you're ill. What is it, girl?' He danced around in between her moving feet and stroked her trunk. Then he stood on tiptoes and rubbed her cheeks and stroked her lips. Nala loved to be stroked. Even though her skin was an inch thick, it was as sensitive as a baby's. He checked her over, but he couldn't find anything wrong – she felt just the same as normal, neither too hot nor too cold. She didn't seem to be in pain, either.

She's crying, thought Sunan suddenly. That was the only way he could describe the noise she was making. The huge creature was crying like a child who'd just had a terrible nightmare.

'Is that what it is? Have you been dreaming? Silly old thing,' scolded Sunan gently. He grabbed hold of her trunk and blew on the end of it. Nala stopped moving and looked at him. He did it again and she shuddered slightly – his breath tickled.

'It's not even time to get up yet. I could have had another hour in bed,' grumbled Sunan. But he carried on caressing her and, gradually, Nala calmed down. He fed her a bunch of bananas, which she munched up, skins, stalks and all, like a big yellow sweet.

Sunan was anxious. He had wanted to look after Nala well, but it had scared him. What if something went wrong? And now it had...

He was wide awake with no chance of getting back to sleep, but he curled up next to Nala anyway. The elephant seemed comforted by his presence. Sunan was reminded of the times he'd had bad dreams and gone to his mother's bed for comfort. This was just the same. It was just that Nala was a hundred times bigger than any child.

Sunan lay on the ground, fidgeting uncomfortably and feeling the anxiety in his stomach worm away at him as the dawn began to clear the darkness out of the sky.

Later, he took Nala up into the jungle for her morning bath and feed with the other elephants and their keepers. She seemed happy enough as she swayed along the path with the other elephants, but how could he tell what was going on in that big old head? When they reached the river, Nala splashed about in the water and lay back with a big sigh as Sunan rubbed her all over with a stiff broom.

'Big baby,' he crooned to her. Her eyes with their long, girlish eyelashes flicked as he splashed water on her face. She looks tired, Sunan thought, but there was no other trace of her panic in the night. What could it have been? Do elephants have nightmares, he wondered? Was it a cruel keeper, or a hunter, who had come to scare her in a dream? Or something less familiar – a giant, perhaps? Sunan shook his head as he tried to imagine what sort of giant would scare an elephant! How big it would have to be, an elephant giant! Such a thing could crush him and his entire village without even noticing.

After her bath and breakfast of fresh jungle greens and more bananas,

they made their way down to the beach to get ready for the day. They worked with fifteen other elephants, giving rides to tourists. The set-up was very simple – a tall wooden platform with a ladder for the tourists to climb up onto the elephant's back. Everyday, Nala took up to eight people on a trek, which lasted a couple of hours and went along the beach, up into the jungle, across the river and back. She didn't earn much for Sunan and his family, but it was enough.

When they got to the platform, Sunan jumped down from Nala's back and chained her to a great stake, over two metres long, driven right up to its shoulders in the sand. Nala was a quiet old beast, she'd never tried to run off and plunder the banana and rice plantations nearby like some of the other elephants. The stake was more to make the tourists feel safe, but nevertheless it was a huge thing, driven so deep that it barely quivered in the sand even if you gave it a good hard kick. It looked solid enough, but it had never been put to the test.

The beach was filling up with tourists already. Some people were having a swim – the water was warm at any time, day or night. Others were walking by the sea, and some were sitting in chairs at the bars and restaurants to have breakfast or coffee and watch the sun rise and the day begin to blaze.

It was about 7.30. Sunan had an hour or so to himself before the first tourists came for a ride. He walked over to sit in the shade of the wooden platform, where he took a packet out of his bag. Nala had eaten her breakfast; now it was his turn.

'Good morning! How's the old girl?' called an English tourist, pink from too much sun the day before, sitting in an aluminium chair a little way off. His smiling wife was standing behind him with a tube of suncream. They'd taken a ride on Nala the day before.

'Good, good, thank you,' replied Sunan, nodding and smiling. 'But not enough sleep.' He nodded towards Nala and shrugged. 'Bad dreams,' he told them. 'She wanted to come into my bed in the middle of the night!'

The tourists laughed at the thought and turned away to face the sea again. Nala herself stood facing the sea, very quiet, her head slightly bowed. Sunan watched her closely. Thoughtfully, she was feeling about in the sand with her trunk, as if the ground was whispering a secret to her. Deep in his

stomach, Sunan could feel a vibration.

He sat still for a second, feeling the slight sensation and wondering what it meant. Then he went to sit down in a patch of shade near one of the beach cafés.

About two minutes later, Nala started to scream.

Sunan jumped up. The elephant was pulling at the stake, her eyes twisting in their sockets. She lifted up her trunk and trumpeted. People around began to back away from her – she was going mad! The two English tourists jumped up and ran off, and even Sunan hesitated before flinging himself at Nala to try to calm her down. He seized her trunk and tried to stroke it, but she was pulling and turning so hard he couldn't hold on. She took a short run on her chain and, in one sudden tug, jerked the great spike out of the ground. Pushing Sunan to the ground with her trunk, she wheeled around, bellowed like a bull – like a dozen bulls – and then charged up the beach, running as fast as a racehorse, her chain and that big stake slithering over the ground behind her. All around, people scattered. Mad elephant! She'd crush them all like beetles!

'Nala!' screamed Sunan. But she took no notice.

As the huge beast went hurtling up the beach towards the jungle, she pushed a great wave of people in front of her, mainly tourists who looked like a flock of hens as they ran and fell and fled. It was awful. Nala was actually chasing the customers away!

Sunan had never seen anything like it. With a wail of despair, he ran after her.

'Nala, Nala, come back! What's wrong? It's all right! Nala, come back, come back!' he yelled. But Nala didn't even pause or turn her head. Those left on the beach heard the elephant's bellowing and Sunan's desperate cries get fainter as they headed towards the jungle. Gradually calm returned. The café and restaurant owners sighed and got back to business; the swimmers, runners and sunbathers, who had moved away from the panic, drifted back. The waves continued to break calmly on the beach.

'That's enough drama for one day,' said the pink Englishman, rearranging his beach umbrella. His wife began rubbing suncream onto his back again. They had hidden behind the bar when Nala broke free.

'I hope that poor lad gets her back. She's his whole livelihood,' she said.

'To think we were on that elephant only yesterday!' The man shook his head and grunted. 'They ought to do MOTs on them, make sure they're up to scratch.' He sighed and lay back to relax in the sun. The two of them had less than half an hour left to live.

Sunan caught up with Nala soon enough; she hadn't gone far. She was standing on a clear rise just before the jungle, staring quietly down towards the sea. Sunan approached her carefully, in case she went mad again, but whatever it was that had spooked her was gone again, it seemed. Nala raised her trunk in greeting, but she wouldn't go to Sunan when he called, and he had to go to her instead.

'You wicked thing,' he told her, waving his stick in her face... but he hadn't the heart to punish her properly. Her behaviour wasn't disobedience. Anyway, the damage was done.

'No one in their right mind will sit on your back now,' he told her sadly. 'Who wants to ride on a mad elephant, tell me that, huh?' He felt like crying. Everything had gone wrong. He felt useless.

Nala just dusted her knees with her trunk, flapped her ears, and looked out to sea.

It was a fine view from where they were standing – they could see right down to the beach about a kilometre away. The number of tourists had thickened up again and he could see the other elephants lining up by the wooden platform for people to clamber on board. A line of elephants was already marching happily from the beach towards the jungle, carrying a little cluster of brightly coloured tourists, who were swaying back and forth on top of the animals.

But there was something a bit strange about that day, about the view across the bay. Raising his hand to his eyes, Sunan looked out over the water and saw a most strange thing. Across the ocean, right across the sea, was a white line. It was quite thick and it was moving towards the coast with the slow grace of a silver jet plane high in the sky. It made Sunan feel cross – he was missing out on something else now because of his stupid elephant! – but at the same time he felt his heart begin to beat. He knew without

thinking about it that the progress of the white line, like that of a jet plane, seemed to be slow only because it was so far away. In fact, it was hurtling along at a terrible rate.

'It's a wave,' he exclaimed. And in that moment he knew that something dreadful was about to happen. A giant wave – a tsunami! Already, as it got rapidly closer, the white line was grower bigger and bigger and seemed to be moving faster and faster. It was a wall of water, a great, fast-flowing river rolling forward on its side, and in just a few minutes it was going to sweep across the beach, drowning everyone in its path, crushing them and everything else in its way, sweeping their remains before it, at a speed of hundreds of kilometres an hour.

Suddenly, Sunan realised. 'You knew!' he gasped. Nala had known – somehow. This is what had been worrying her last night, this is what had scared her – a tsunami! But how?

Sunan grabbed her trunk and stroked it. She had saved his life as well as her own. If he hadn't chased her, he would be down there too. In fact, she had saved many lives already. All those tourists she had chased off the beach and who hadn't yet come back.

The people had to be warned. Sunan tried shouting a couple of times, but he was too far away. It was no use. And now the white line was beginning to roar as it swept into the shallower water. He managed to get Nala to trumpet, but even that didn't work – no one paid any attention to her; instead, heads were turning out to sea. At last, the people on the beach were beginning to see the wave, but they still didn't realise what was happening. Nala's nightmare was upon them – a giant that could sweep whole herds of elephants in front of it, that could crush buildings and flatten forests. It was coming down on them with the speed of a jet plane.

All Sunan could do was stand with Nala and watch in horror as the wave moved gracefully forward, on its journey of death.

As it approached the land, the wave seemed to gather itself up, pulling back the water from the beach and leaving a host of sea secrets briefly exposed to the air – stranded fish, shells, starfish and other sea creatures that had been left behind. The people who hadn't yet seen the wave, began to walk down, actually towards the impending destruction, to explore this new

area and to treasure-hunt the beach.

Again Sunan tried to yell, but any sound the people on the beach might have heard was cut out by the sea.

Then at last, people began to realise what was happening – the wall of water was roaring towards them. They began to back off and then, as they understood that the wave was travelling hundreds of times faster than usual, they began to run. Now the wave showed its true nature. Boats a few hundred metres off the shore began to rise up on its broad back and tip over like toys. People were running now, and screaming, although nothing could be heard but the roar of water – and then the wave hit the beach.

Even from up on their hilltop, Sunan and Nala could hear the noise it made, like a train crashing. It rushed over the people, swallowing them like little ants sucked under a giant mower. The white water suddenly turned dirty. Underneath it, Sunan could see people disappearing, the cafés and restaurants breaking up, beach umbrellas swallowed whole. It was like a living monster.

Sunan and Nala watched it all. Directly in front of them, a group of people were running for their lives. Among them were some small children. The adults tried to help them, but the children just could not go fast enough and they were getting rapidly left behind. The water was racing after them, reaching out to them. The land was breaking the wave up, but still it was coming, slower now, but still deadly.

The wave broke, boiled, surged up the beach, crawling and grabbing its way further than anyone would have thought possible. Then the inevitable happened – the water caught up with the children, swished them off their feet and shoved them further up the beach, all mixed up with other bodies and rubbish caught in the torrent of water.

At last, the wave began to subside. It calmed, and began to pull back towards the sea, its giant hands scraping its plunder along the sand, releasing bits of broken masonry, toppled trees, boats and bodies, but taking a great deal more away with it. Some people got up again; many did not. Many never would.

Sunan searched about for the group of children. A couple of them were staggering about; some lying on the sand. Not all were dead!

'Quick, Nala — it's safe now!' he yelled. The great animal bent her knee for him to climb onto her back and the two of them went charging back down to the beach to help. It took only a minute to reach the place of devastation. Sunan could hardly recognise this once-familiar place. Water was everywhere, structures were still toppling down and sinking into the dirty water. The wooden platform was nowhere to be seen and great heaps of debris were scattered everywhere. People were staggering about looking for help, many of them bleeding. It had been such a friendly place, but now it was a war zone. Floating in the water, trapped behind a car that had been turned upside down, Sunan recognised the pink man he had spoken to earlier. One look at his face told him enough — the man was dead. His wife was nowhere to be seen.

Sunan urged Nala on — what if another wave came? — and Nala knew what had to be done. Whenever she saw some children, or Sunan pointed them out, she lumbered forward, splashing through the water, and seized hold of them with her trunk, lifting them up, one by one, and plopping them neatly down on her back, like a row of bedraggled teddy bears. She was rushing; she wanted to get away from there as much as Sunan did. From his vantage point on her back, he raised his eyes to look at the sea. Already he could see another wave, still far away. But whereas the first wave had been white against the blue water, this one was black.

Nala ran about the wreckage, squealing with anxiety as she plucked the children to safety. Pretty soon she had ten children on her back — they could see no more. The black line on the water had grown into a towering wall now, and already they could hear the noise of it. It was even bigger than the first one, and it was moving faster. With another great bellow, Nala turned and ran for it. Sunan and the children hung on for dear life, bumping and banging and grabbing hold of any bit of elephant they could as she rushed like a lorry up the beach and onto the higher ground in front of the jungle. She ran as if she was being pursued by a monster — which she was. She ran and ran and ran... and, at last, panting with exertion, she stopped and turned to face the screaming sea. The children and Sunan slid to the ground like a series of ripe fruits falling off a tree.

Behind them was a terrible roaring noise as the wave broke.

This wave was two or three times bigger than the last one, full of black dirt from the seabed. It came charging up the beach, flattening everything in its path, turning land into sea. Boiling and seething, it rushed up the beach, far beyond the point where the previous wave had reached, and tore up the hill and into the jungle. It still had enough strength to rip the trees out of the ground and toss them behind it like sticks. On and on it rushed, closer and closer to the point where Nala, Sunan and the children stood. Some of the young ones began to scream and cry, but Sunan knew it was going to be all right because Nala was calmly standing still, waiting and watching.

Gradually, even this monster wave spent its force and began to calm down. By the time it reached them, it was just a slow arc of dirty water, lapping softly at their toes with no more strength than a baby. Nala had taken them exactly far enough, and no more.

It was over. Before them stretched devastation and death. It had all taken just a few minutes, but Sunan knew nothing would ever be the same again.

'Look, it's just a puddle now,' shouted one of the little boys, and he began to throw stones at the retreating water.

A refuge for Thai children

SOS Children has been working in Thailand for more than 30 years and it has set up three villages in the country that look after or house more than 200 children. Many of the 'real' Sunan's friends will be forced to work to earn money for their families, and the communities set up by SOS Children in Thailand provide these children with a welcome refuge from the harsh realities of daily life. Miraculously, none of the villages in Thailand were damaged in the tsunami, and they continue to provide a safe world where children can play, learn and laugh – in other words, where children can actually be children!

What Liyoni Saw

GILLIAN CROSS

Liyoni stood outside the front of her house, with her eyes tightly shut. She was remembering the blind man she had met last week. He had come limping along the main road while she was up at the library. When she came out, she'd seen him tapping at the ground with his stick and felt sorry for him. Because it was hot and dusty, she'd run down into the village to fetch him a cup of water.

And as he took the water, he'd smiled. The happiest smile she had ever seen. 'The world is good,' he'd said.

He had nothing. He was old and poor, and he couldn't even see the bright stalls along the main road or the sun on the papaya trees. How could he say, *The world is good*?

Liyoni stood with her eyes closed, shutting out the familiar sights around her. Her grandmother's house. The houses where her uncles and aunties and cousins lived. The tall, tall palm trees with their long, fringed leaves.

Suppose I was blind. Suppose I could never see the trees, the houses, my family again. How would I feel? Would I still be able to say, The world is good?

'Hey! Liyoni! What are you doing?'

It was her friend Seba. Liyoni's eyes flew open and she saw Seba walking towards her with a crowd of other girls. They were heading out of the village, off to religious school.

'Aren't you ready?' Seba said. 'We'll be late if we don't go now.'

'Of course I'm ready,' said Liyoni. 'And I can walk twice as fast as you can!' She set off at top speed and the other girls hurried to catch her up,

laughing and chattering.

They were almost halfway to the school when someone came racing towards them, out of the village. It was Liyoni's youngest uncle. She grinned and waved her hand at him.

But he wasn't smiling. 'Don't go that way!' he panted, as soon as he was near enough to speak. 'Make for the main road. The sea has gone mad. There's a huge wave coming. We have to get to the highest ground we can reach!'

The group of girls stood in silence for a moment, trying to understand what he had said. Then some of them started to panic, but all Liyoni could think of was the house she had just left. And all the other family houses clustered round it. The land where they stood was very low. If she ran off to the main road, how would her family know about the danger?

'We can't just run away,' she said. 'What about everyone else? We have to go back and warn them, Uncle. If we don't tell them…' She broke off short. She didn't want to think about what might happen then.

Her uncle looked wildly at her. 'There's not much time. The water would be here already if the lagoon wasn't in the way. We have to take our chance now.'

'Not before we've told the others!' Liyoni said. 'Come on!'

Some of the girls ran the other way, towards the main road, but Liyoni and her uncle raced back down the road, as fast as they could. Before they even reached the village, they were both shouting warnings.

'Run! Run for your lives! There's a giant wave coming!'

'Go up higher! Before the water gets here!'

When they reached the open space in the middle of the houses, they found it full of people, all panicking and shouting.

'…hundreds of people dead…'

'…can't be as close as that…'

'…a great black wave of water, taller than all the houses…'

Why were they talking? Why weren't they *running*? Couldn't they see how dangerous it was to stay in such a low, low place? She wanted to tell them, but she couldn't make her voice heard above all the noise.

She raced across to her father and tugged at his sleeve. 'Everyone's wasting time!' she said frantically. 'We have to get away to somewhere high – like the library! Please make them hear!' Her father had a huge voice.

When he laughed, the house shook. He *had* to make them hear. 'The library!' she said again.

Her father looked down at her and nodded. Then he stepped back from the crowd and bellowed as loudly as he could. 'COME THIS WAY! TO THE LIBRARY!'

Then he picked up Liyoni's little brother and set off towards the main road, looking over his shoulder to make sure that Liyoni and her mother were following.

By the time they reached the library, it was already half full. It had only one room, and families were crowding together in the spaces between the tall bookcases. Liyoni had spent many happy hours browsing in those bookcases, but now they just seemed like obstacles. They shut her in, blocking her view as she tried to check that everyone was there.

'Where's Auntie Minrada?' she said. 'I can't see her anywhere.'

'She'll be here soon,' her mother said soothingly. 'It's hard for her to run.'

That was true, of course. Auntie Minrada was round and cheerful and she got out of breath very easily. She was probably still on her way to the library. Liyoni wedged herself into a corner near the door, watching the people flocking up from the village. Some of them were carrying food or bundles of blankets. Some of them had nothing – they had come just as they were, rushing up in a panic.

But Auntie Minrada didn't come.

After a while, nobody came. Then there was no sound outside except a terrible crashing noise of water, very close to them. Much closer than any water should have been.

There were nearly a hundred people crammed into the library by then, but there was none of the usual talk and laughter. Just serious faces and soft, muttered words.

'Pray,' Liyoni heard people saying all round her. 'Keep praying.'

She tried, as hard as she could, but it was impossible to concentrate. Her little brother was scared and tired, and he kept whimpering and whispering in her ear.

'I can hear the sea, Liyoni. It's coming to get us. Listen. It's getting nearer.'

'Sshh,' Liyoni said. Not once, but dozens of times. 'I've told you. We're

safe here. The water can't reach this high.'

'How do you know? It sounds as though it's right at the door. Go and see, Liyoni.'

'I won't be able to see anything. It's dark outside now. But we're safe. All we have to do is wait for the water to go down.'

'But what if it doesn't? What if it gets higher?'

He was getting more and more agitated. Liyoni realised that she had to stop him listening to the noise of the water. Leaning back against the nearest bookcase, she pulled him towards her and wrapped her arms around him.

'Do you want me to tell you a story?' she said.

For the first time, he stopped whimpering. 'What story?'

Liyoni looked along the bookshelves and thought of all the wonderful stories she'd found there. 'I'll tell you a story about a monkey and a snake,' she said. Because that was the longest one she knew. He shuffled closer, looking curious, and she began in a soft, gentle voice.

'Once upon a time, there was a monkey who wanted to see the world...'

Liyoni didn't know exactly when she fell asleep. But when she woke, her throat was sore from telling story after story. She swallowed and sat up, rubbing her eyes.

It was light now, and inside the library, most people were still asleep, curled up on the floor between the bookshelves. But her father was stirring. She saw him open his eyes.

'Has the water gone away?' she asked softly.

Her father stood up and went to the window. He didn't say anything. Just stood looking out. After a moment or two, Liyoni got up and went to join him, stepping carefully around the sleepers in between. For a moment, when she looked out of the window, she didn't know what she was seeing.

The library was at the highest point on the main road and normally the window had a fine view of the papaya trees and all the stalls selling bangles and drinks and snacks.

Not now, though. Everything had changed. The water had gone down, but the stalls right outside the library were lurching sideways. And further down the hill, everything familiar had disappeared. The ground was littered

with fallen tree trunks and stones and shreds of tattered cloth. Nothing was moving.

Inside the library, more people were waking up now. Liyoni could hear little children complaining to their mothers.

'I don't like it here.'

'Take us back.'

'I want to go home.'

Liyoni's father sighed. 'Yes,' he said sadly. 'It's time to go back home.'

Yesterday, looking round at their family houses, she'd thought, *Suppose I could never see them again. How would I feel?*

Now she knew. Not because she was blind, but because everything had changed. All the houses except their own were smashed to pieces. There was nothing left but a scattering of tattered palm trees rising out of heaps of sand and jagged brick. The air was thick with a sweet, rotting smell. Virtually the whole village had been destroyed and everywhere there was a stench of death.

Their own house was seriously damaged. It had lost half its roof and the walls were full of huge, ragged holes. Her father stood staring at it and his face was twisted with pain and grief. He began to cry.

That was when Liyoni really understood how bad it was. She hadn't thought there was anything in the whole world that could make her father cry. He was too strong, too brave. But he was crying now. And her mother was sobbing too, with Liyoni's little brother clutched in her arms.

Liyoni thought of the blind man again. She remembered his calm face. His patient, tapping walk and the smile he'd given her when she brought the water. She touched her father's arm.

'Let's go inside. Maybe we can rescue something.'

There was no door to open. She led him through the empty doorway and into the space that had been her bedroom. It should have been full of clothes and books and pens. All the pretty things she'd collected and the pictures she'd drawn. Her father stood with his back to the wall and looked round gloomily.

'It's all gone,' he said. 'Everything.'

He was right. There was nothing left. The water had swept through, carrying everything away and leaving heaps of stinking sand behind it. Liyoni could see the marks of the floodwater high on the wall above her father's head.

But she wouldn't give in to the sadness she felt. She was determined to find something to make her father feel more cheerful.

'*Everything's* gone,' she said bravely. 'Not just the good things, but the bad ones too. That means we can make a new start.' And she spread her arms wide to show how many good things there were ahead of them.

'What's that?' said a voice from outside. 'Is someone ready to make a start?'

It was her eldest uncle. He stepped into the house and Liyoni saw that he was carrying a sack.

'They've sent us shovels from the town,' he said. 'So we can dig the sand out of our houses. But we'll need to begin straightaway if we want to clear a space to sleep in tonight.'

'I'll help,' Liyoni said eagerly. But as she stepped forward to take a shovel, something squelched under her foot.

It was a dead bird.

Its eyes were dull and insects were crawling over its dirty feathers. She thought she was going to be sick. Before she could stop herself, she started to cry. Her father pulled her into his arms and she leaned against him, sobbing and retching. He stroked her hair and let her cry.

When she managed to stop, he said, 'Your uncles and I will do the digging, Liyoni. You've been very strong, but you can't do this. Go outside and leave it to us.'

Liyoni nodded wearily and walked out of the house. Her mother and her little brother were on the other side of the village, hunting through the rubble, but she couldn't bear to join them. Not yet. Everything was so strange and horrible that she longed for something normal. Something that was the same as it had always been. Before the sea went mad.

The houses were all smashed, but some of the trees were still standing. It was good to see the big old palm tree on the edge of the village. Since she was a little girl, she and her friends had gathered underneath it to chatter and

play. If she could stand underneath it for a few moments and run her hands over its familiar trunk, maybe she would feel calmer.

She started to pick her way through the debris to reach the tree. There was a pile of sand and shattered wood heaped up against its trunk, making it look shorter, as though it had somehow sunk down into the ground.

But not only sand and wood. As she got closer, she realised that there was something else tangled up with the rubble. Something big, bent awkwardly round the trunk. Its long black hair trailed like seaweed, and under the strands of hair, she could see bright colours. Pink and yellow and blue.

Auntie Minrada's sari.

There was no mistaking the sari. Auntie Minrada always wore bright colours, as bright as her round, jolly face. As strong and clear as her lovely, singing voice. Liyoni's feet kept walking towards the tree. It was as though they wouldn't stop until she had climbed the heap of sand and looked down at her auntie's dead, discoloured face.

She could hear her mother's voice over by the house, calling to her little brother, and she wanted to scream and fling herself towards them, wailing out what she'd found. She wanted her mother to run towards her, sweeping her into a hug that would blot away the horror. Her mouth was already open to yell, and she was turning round to run.

But then – just in time – she stopped. She remembered that Auntie Minrada was not just an aunt. She was a sister too, her mother's sister. It would be a hundred times worse for her mother. And it would be even more painful if she heard it from a hysterical, screaming daughter.

Liyoni closed her eyes, to shut out the sight of her aunt's poor, bloated body. Deliberately, in the darkness behind her eyes, she made a different picture of Auntie Minrada. Beautiful and jolly and full of life. Holding that picture in her mind, she opened her eyes and walked slowly back to the house, to tell her mother what she had found.

That night, the whole family slept on the floor in Liyoni's house, even though there were holes in the walls. They crowded together into the two rooms that still had a roof, and Liyoni went to sleep surrounded by the people she loved. Her brother and her parents. Her grandmother. Her aunts

and uncles and cousins.

She woke in the middle of the night, and found herself staring out through the great hole where her bedroom window had been. The sea was still wild and noisy, but the sky was clear. The stars were more beautiful than she had ever seen them before. Was Auntie Minrada up there somewhere, looking down at her?

Liyoni lay on her back and watched the sky. She didn't forget the things she'd seen. The dead bird and the ruined houses. The bright, bright sari and the long dark hair spread over the stinking sand. They were horrible, but they weren't the only things in the world. The stars hadn't changed. Somehow – in a way she didn't understand – everything worked together in harmony. For the first time, she felt that she was beginning to understand the blind man.

The world is good, she thought.

Y Care International helps Liyoni

Since the tsunami, the family of the 'real' Liyoni has received support from the local partner of Y Care International, the YMCA of Sri Lanka. In the days after the disaster, volunteers at Kallar YMCA set up four tents to provide shelter for her extended family, and they rebuilt the village well system, which was destroyed by the waves. The local YMCA has also been providing children with educational materials and school fees, as well as with trauma counselling to help them recover from their ordeal. What made 'Liyoni' smile most though, was when the aid worker who provided the outline of her story gave her some school supplies, which the YMCA had been distributing to different schools in the community – 'Liyoni' was finally able to write down the stories that she loved telling so much!

About the Charities

Aid workers from the five charities listed below worked with children who had survived the tsunami and collected the details of their experiences. It is these details that inspired many of the stories in this book. Proceeds from the sales of *Higher Ground* will benefit these charities' invaluable work and help not only the children who suffered as a result of the tsunami, but many other children all over the world.

Handicap International

Working in more than 55 countries worldwide, Handicap International's mission is to work with disabled people and vulnerable populations to make a positive difference to their lives.

During the last 23 years, Handicap International has developed a 'holistic' approach to disability, aiming to address all the issues that surround it. The organisation works towards: disability prevention, through activities such as bomb clearance and raising HIV/AIDS awareness; provision of rehabilitation services, such as physiotherapy and orthopaedics equipment; the inclusion of disabled people, through projects such as inclusive education and lobbying for disability rights; and capacity building of local and national associations.

Handicap International is co-winner of the 1997 Nobel Peace Prize.

For more information, please visit www.handicap-international.org.uk.

Save the Children

Save the Children fights for children in the UK and around the world who suffer from poverty, disease, injustice and violence. The charity delivers immediate and lasting improvement to children's lives worldwide.

Children are particularly vulnerable in emergencies because they are physically weaker than adults and risk being separated from their families. Emergencies blight childhood, a crucial time for developing and learning. Save the Children began life as an emergency-relief agency, now they also address long-term recovery and development. The emphasis is on preventing disasters where possible, and finding sustainable solutions.

For more information, please go to www.savethechildren.org.uk.

SOS Children

SOS Children is the world's largest orphan charity, looking after children who have lost their parents because of war, famine, disease, poverty or natural disasters such as the 2004 Asian tsunami.

SOS Children cares for more than 50,000 children directly and, it helps about 500,000 more, including more than 50,000 African AIDS orphans, through nurse visits, education, vocational training centres and social and medical centres. The organisation enables children to live according to their own culture and religion, becoming active members of their community by receiving the education and skills-training that they need to be independent.

For more information, please visit www.soschildren.org.

UNICEF

UNICEF, the United Nations Children's Fund, is the world's largest development organisation working specifically for children and children's rights. Its goal is to promote dignity, security and self-fulfilment for all children, everywhere. UNICEF works with local communities, organisations and governments in 157 countries across the globe to advocate children's rights, to help meet their basic needs and to expand their opportunities to reach their full potential. This is achieved through long-term development programmes, as well as emergency work in times of crisis.

In developed countries, the organisation works to win support for children's rights by campaigning on national and international children's issues, and to raise money to fund UNICEF's programmes internationally.

To find out more about UNICEF, please visit www.unicef.org.uk.

Y Care International

Y Care International is the international development and relief agency of the YMCA movement in the UK and Ireland. It works in partnership with YMCAs in the developing world, funding and supporting sustainable and effective grassroots development programmes that help young people lift themselves out of poverty.

When there is a disaster, YMCAs around the globe are able to mobilise quickly and effectively, and as longstanding community-based organisations, they are in a strong position to identify their communities' needs, and are committed to long-term rehabilitation.

Find out more about Y Care International's work, including its long-term tsunami response, at www.ycare.org.uk.

The following two charities, which provided illustrations for *Higher Ground*, continue to work in tsunami-affected regions:

MCC

Mennonite Central Committee (MCC) is a relief, development and peace agency in Canada and the United States. MCC staff and volunteers care for those who suffer from hunger, homelessness, poverty, oppression and disease in more than 55 countries through agricultural development, vocational training, conflict resolution, education, public health and HIV/AIDS assistance, and by improving water sources and providing emergency aid.

To find out more about them, and how you can donate, please visit www.mcc.org.

Youth Off the Streets

Youth Off The Streets, based in Australia, set up the Children's Care Centre in Aceh province, Sumatra, operated in partnership with Muhammadiyah, one of Indonesia's largest Muslim organisations. The centre continues to provide accommodation, medical attention, counselling and access to education for survivors of the tsunami.

For further information, visit www.youthoffthestreets.com.au.

And visit the *Higher Ground* website at www.highergroundproject.org.uk.

About Anuj

Anuj Goyal was born in London in 1977. He studied English at Somerville College, Oxford, where he founded and produced the New Writing Drama Festival. After graduating, Anuj joined the BBC Production Trainee scheme, directing Newsround and producing Woman's Hour. He was the first trainee to work abroad at BBC America, Washington DC, where he covered the 9/11 attacks. From 2002, Anuj was a director of Blue Peter and a year later, he won the Royal Mail Innovation Award for Journalistic Excellence. In 2004, Anuj left to begin work on a children's novel – and then the tsunami hit.

Anuj also freelances as a writer and filmmaker. His media company, *feature*, developed and managed the *Higher Ground* project. If you have any questions for Anuj, please contact him at www.featurefactory.co.uk.

Acknowledgments

Anuj would like to thank the following for their advice, good faith, and patience:

The authors, for being so committed to my harebrained idea from the very start, and sticking with me during a very trying nine months; Michael Foreman, for his wonderful cover illustration; The charities – Mary Wolfe (SOS Children), Beatrice Cami (Handicap International), Helen Masding (Y Care International), Laura Conrad and Fay Mahdi (Save the Children), Julia Gorton and Paula Plaza, (UNICEF), and, of course, all the field workers in the affected regions.

At *Chrysalis Children's Books*: Sarah Fabiny and Ben Cameron, without whose faith this book would simply not exist; Hannah Wilson, for her incredible work in editing the sixteen stories and putting the book together; Frances and Tamryn, for getting me through the Everest of contracts, agreements and addenda.

BBC: World Service producers (Tamil, Hindi, Sinhala, Somali, Thai, Indonesia sections) for helping me research the cultural background behind every story; Steve Hocking and Alison Cresswell, whose early advice helped me turn my idea into reality. Other Publishers: Liz Cross (OUP), Rebecca McNally (Puffin), Gillie Russell (HarperCollins), for their guidance in an alien world. President Bill Clinton, UN Special Envoy for Tsunami Recovery, for his message of best wishes.

Personally, I must also thank: Rosie Gregory, David Hills, Sam Gyimah, Dave Hamilton, for being the solid core of my ever-shrinking social circle; my brother, Niraj, for the use of his laptop and phone at often antisocial times of the day. But, above all, three quite extraordinary people: my partner, Kara Alicia Miller, for her ruthless optimism and categorical support no matter what I want to try to do; and finally, mum and dad, Santosh and Dil Goyal, for... well, where should I begin?... for pretty much everything!

Thank you.

Picture Acknowledgments

The publisher would like to thank the following for their kind permission to reproduce the photographs and illustrations in this book:

p2, 8 © Y Care International; p9, 18/plate 8 © Youth Off the Streets, Australia; p12/54, 36/110, 64/plate 4, 80/plate 1, 92/118/plate 2, 100/128/plate 7, 138/plate 6 © Brenda J Burkholder, MCC; p24/46/148/plate 5 © UNICEF/HQ05-0357/Giaconio Pirozzi; p72/plate 3 © UNICEF/HQ05-0359/ Giaconio Pirozzi

All reasonable efforts have been made to ensure that the reproduction of content has been done with the consent of copyright owners. If you are aware of any unintentional omissions, please contact the publisher directly so that any necessary corrections may be made for future editions.